next
#04

Bego Antón / Bryan Denton / Isadora Kosofsky / Meeri Koutaniemi / Giorgio Di Noto / Émilie Régnier / Raphaela Rosella / Sarker Protick / Bryan Schutmaat / Akos Stiller / Andrejs Strokins / Ilona Szwarc

PARTICIPANTS IN THE
2014 JOOP SWART MASTERCLASS BY
WORLD PRESS PHOTO ACADEMY

IRRESISTIBLE

Schilt Publishing

My Life in the Masterclasses

Each November I have a brief torrid love affair in Amsterdam. I don't even have to be there. These affairs involve more than one person and I am both a bystander and an active participant. This annual stirring of my heart embraces touch, fragility, hope and balance, respect and trust, persistence. Some of these experiences are like hot kisses on my lips, others like the caress of a mother's hand, still others raise my ire at the injustices around us.

As a teacher at, and later nominator for, the Joop Swart Masterclasses, I have seen and learned things for which no words, only the participants' images, will suffice. The twelve young photographers may differ each year, but their purpose is twofold: to give themselves over without hesitation to whatever encouragement, advice, criticism, and experiences we can share, and to show us the world as they see it. This is the Master Class, my April in Paris, my Autumn in New York, my Moonlight in Vermont.

I'm not a writer of steamy novellas, where things happen in the heat of the moment, but that same kind of heart-stirring passion is what I feel for these classes. They have become one of the unabashed joys of my photographic life. Along with other teachers, I admit to being deeply and permanently moved by the shared experiences and work each year. I am the maiden standing on the hill with the wind blowing through my hair, waiting for the ships bearing treasures to roll in on the waves. I am the mama cat alternately petting and smacking her fierce kittens. I am the ardent coach cheering my team on. I am the besotted loyal fan of this very unique occasion, and of the work produced by the participants, which changes lives, both theirs and ours. The experience is sublime.

Entry into the masterclass is not easy, but—after what must always be a subjective decision, based on different ideas about photography and its purpose, about what is interesting, about what works and what does not—an international panel selects a talented group of young photographers, and comes up with a theme for a photo essay. Then, in November, we come together: masters and participants, for a week of sharing work, ideas, clashing opinions, debates, counseling, commenting, editing and re-editing. Everything is personal. Participants share their experiences, their innermost secrets, hopes and fears, their joys, and their expectations of themselves in a world that grows bigger at the same time it is shrinking in opportunities. The best stuff happens when we speak with participants one on one. It's not as if we connect

personally with every participant, but when that does happen, with the brave ones who share personal stories and innermost goals, we are both changed.

My photographic style is reinvigorated by the work of these young people, who go on to do great things, whose bylines appear in premier publications and websites, those who publish books and are intrepid in their opinions and in their ability to speak their minds, and who driven by a sometimes traumatic life. I feel I am standing on the cutting edge of change. That is a thrilling place to be, and has helped me get back to where I started in photography, when I felt so free and that anything was possible—a gift I had not expected.

The participants offer us a wealth of experience: we have seen a life on the rebound from personal desperation of drugs and alienation, shown suddenly in the beauty of rediscovered joy, and we've seen bored youth in an oblique place that was nowhere and seems to have no future. We have seen the hows and whys of anorexia and cutting, portrayed in a personal way; the power of oceans and how people live alongside them; the ravages of war and the men who are stuck in the moment of battle; the hope that exists even in the most impossible Haitian dump filled with burning trash, and so much more. No names are needed here, because in the end it is so much less about who we are and so much more about the who and what and why of the photographs. Sometimes we manage to make photographs that inspire, that bring us to our knees with their majesty and power, that break our hearts, that change us.

All the work from masterclass is personal, no matter what the subject, and shows us the world from the most intimate details to our universal commonalities. Who would not be in love with this glorious collection of human stories? Through their work I look in a mirror and see myself. It is an invitation to walk on the wild side, and a happy reminder to me of why I became a photographer, and why I still call myself a photographer. These are the new warriors, the young lions, and I love running with them, wild across open plains. They might run ahead of me or they might follow me, but we are all members of a family that marks our lives forever, and if we do it right, even now at this point in my life, I believe we can change the world.

Maggie Steber, USA
Photographer, educator, photo editor
Master 2008, 2009, 2010

Boomtown

Bryan Denton

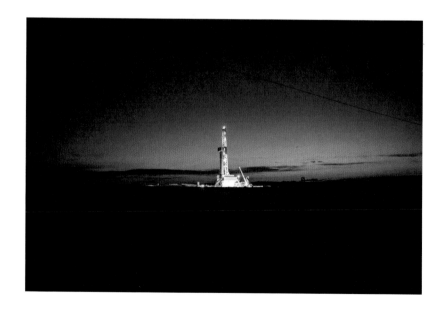

An oil-drilling rig stands illuminated against the night sky, outside Williston, North Dakota.

In the minds of most Americans, the state of North Dakota carries something of the idea of a perennial frontier. Over the past decade, a shale oil boom has hit the region. The Bakken Formation, underlying northwestern areas of the state, has proved to be a lucrative source of oil. The pursuit of the opportunity once promised by verdant farmland has been rekindled— but this time the lure of riches and success is to be found in the extraction of what lies beneath the land: an ocean of oil locked in shale. As the controversial drilling technology to extract the gas and oil has become increasingly viable, the resulting boom has wildly expanded the local economy. Tens of thousands of Americans have been drawn from all over the economically troubled United States to the Bakken region in search of work. The result has been an Americana-infused clash of visions, as small towns have metamorphosed into small cities within just a few years. Wealth, crime and the cost of living have all risen to levels that have displaced many, dissolving old local communities. There has been a clash of landscapes as environment and industry battle for domination of the prairie.

I have always been drawn to photographing places that are in flux. For most of my career, I have focused on covering violent change—revolutions, wars, and social uprisings. The Boomtown project was born out of a desire to explore a place that was being altered by more peaceful, but equally disruptive, forces. Much of the work on the oil boom in the Bakken region that I saw during the research phase of the project focused on overtly negative aspects of the boom, through very orthodox photojournalistic lenses; or on specific corners of the story, such as oil-drilling. My goal was to try to explore what it feels like to be a part of this economic groundswell, exploring the hope, loneliness, isolation, nostalgia and desperation that seem to circulate in equal parts around this part of North Dakota.

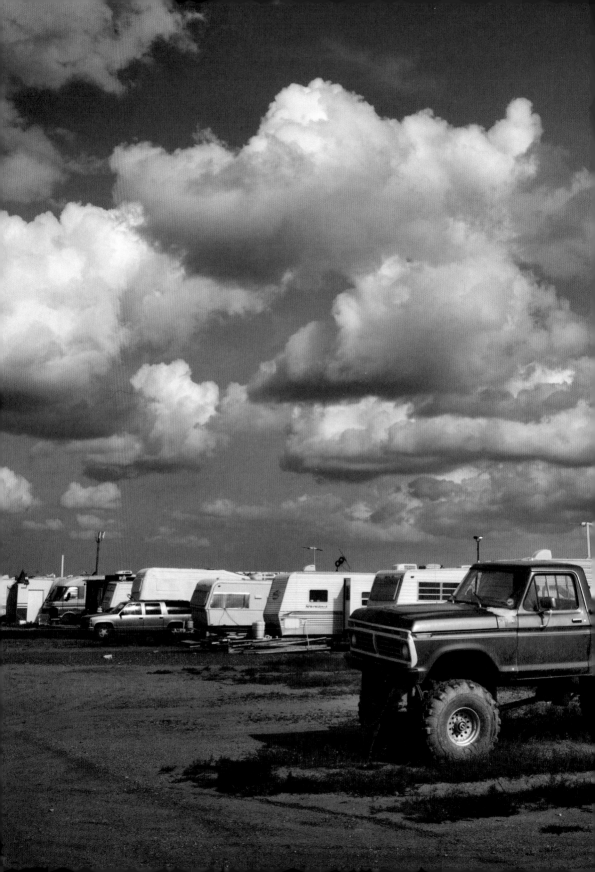

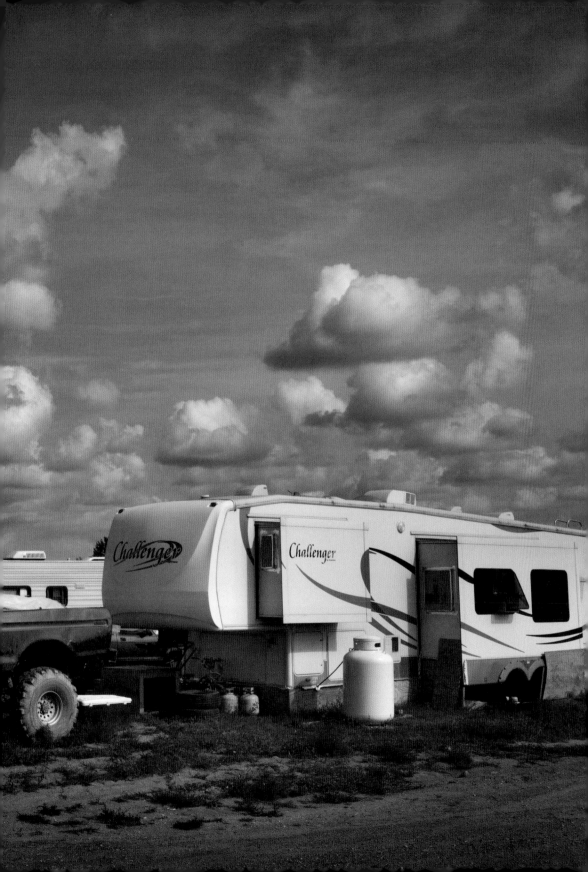

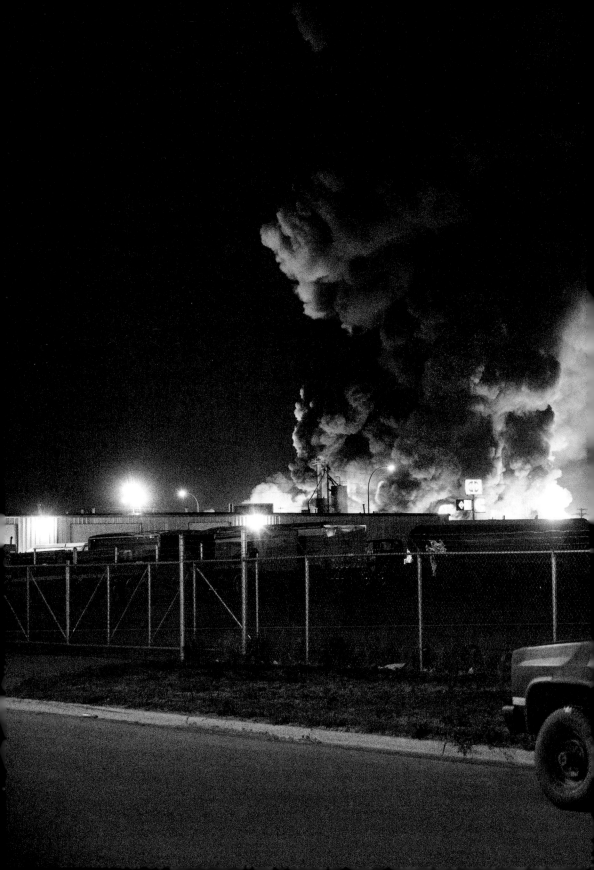

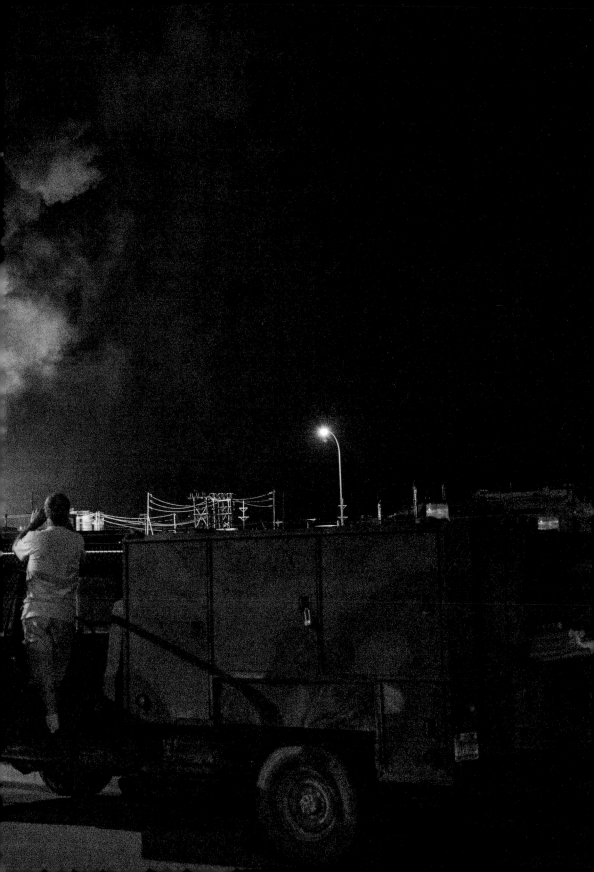

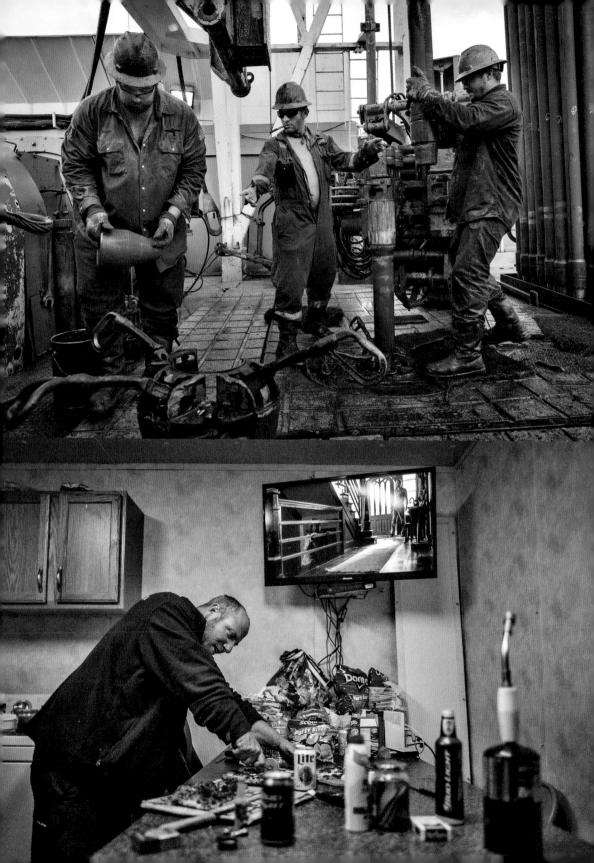

Pages 8-9: The Fox Run RV park outside Williston is home to over 1,000 people. Renting trailer space costs US$850 (€655) a month, whereas a one-bedroom apartment would cost US$2,000 (€1,545). Pages 10-11: A fire fueled by chemicals used in the hydraulic fracturing (fracking) process, burns out of control in an industrial quarter of Williston. Above left: Men work on their rig at Raven Drilling. Four six-man crews work 12-hour shifts to keep drilling operations going continuously. Below left: Bam slices a microwaved pizza at the 'man camp' near the drilling site where he works. The men work seven-day weeks for two weeks, then have a two-week break.

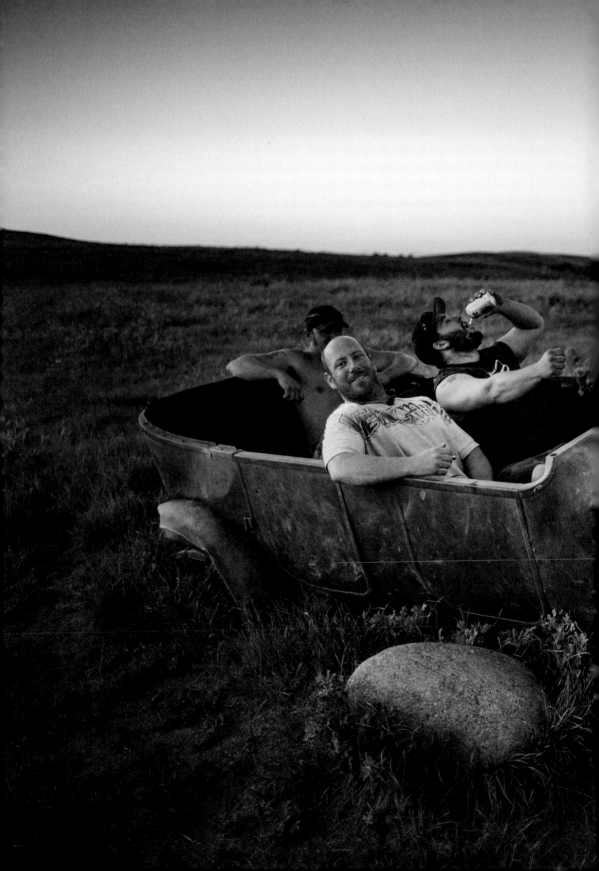

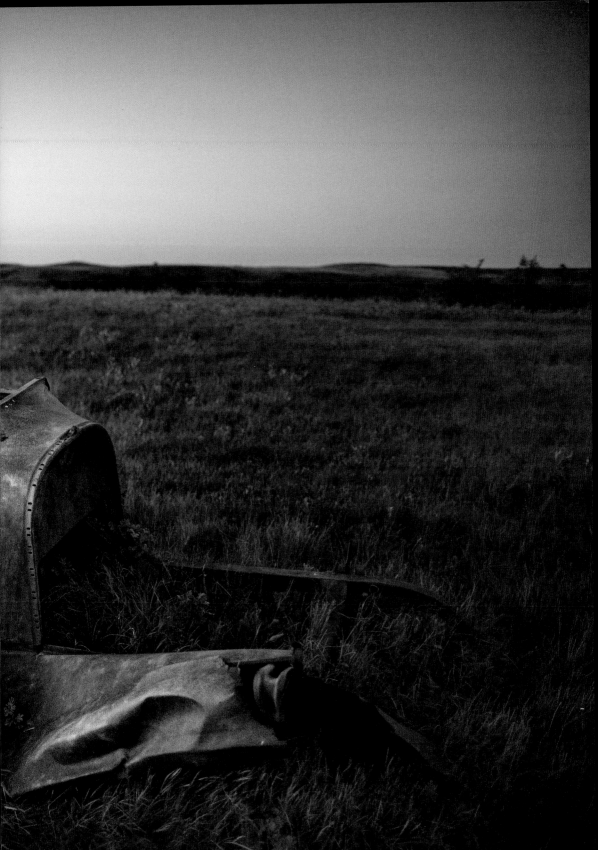

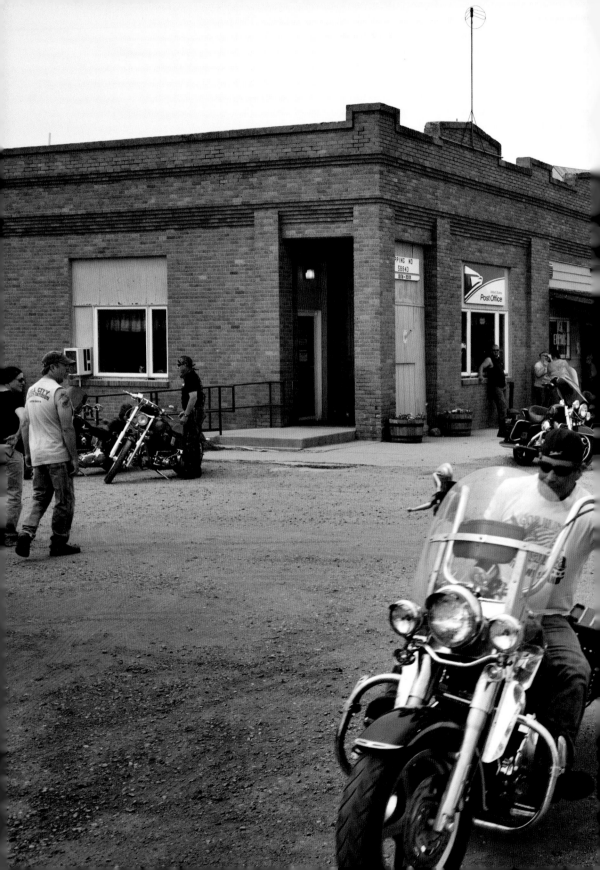

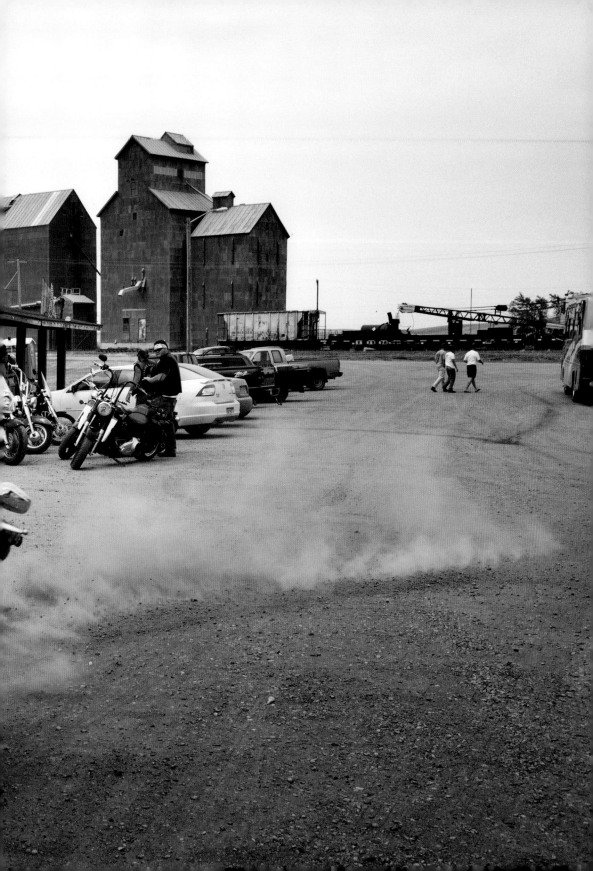

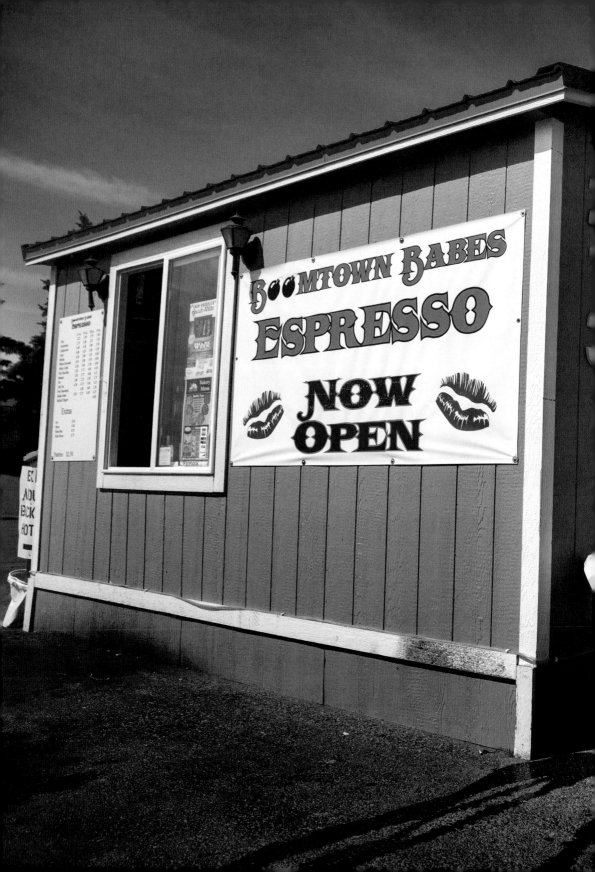

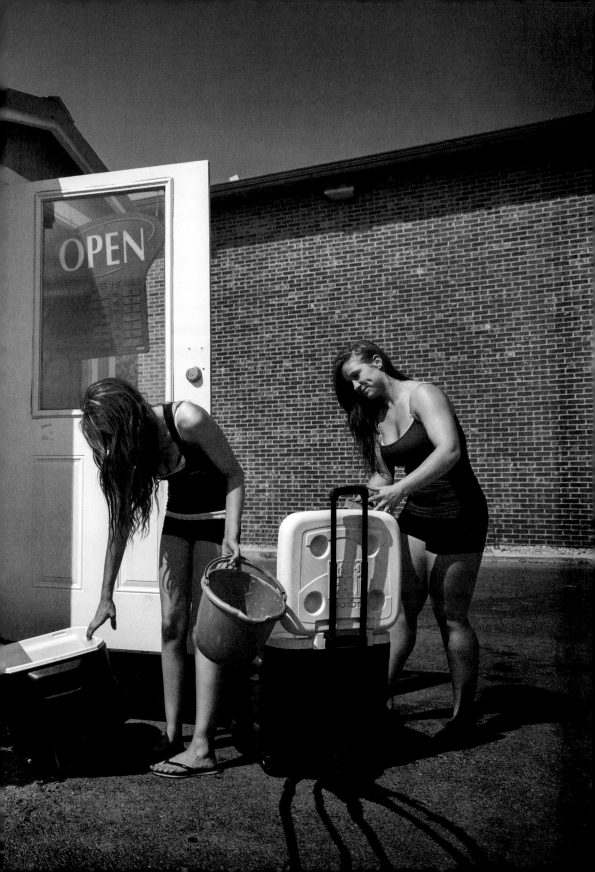

Pages 14-15: Bam (center), Lesbo (with beer), and Phillips fool around in the wreck of an old automobile, while on a 'booze cruise' after their shift, driving in the badlands near their camp. Pages 16-17: A biker peels out of the main intersection in Epping, North Dakota. Pages 18-19: Emily Nowell and Trish Couture wash out containers at a coffee kiosk, where women in tight shorts sell marked-up coffee to a primarily male clientele. As oil-field workers flock to the region, Williston has become overwhelmingly male. Above right: Residents of Williston attend an affordable-housing meeting at the community library. Rents have skyrocketed in recent years. Many living on fixed incomes, especially the elderly, face eviction as they cannot afford the increase. Below right: Men arrive at Williston station in search of work. Many come with little more than a backpack. Following spread: A bison walks along the road near the Theodore Roosevelt National Park, south of Watford City, North Dakota.

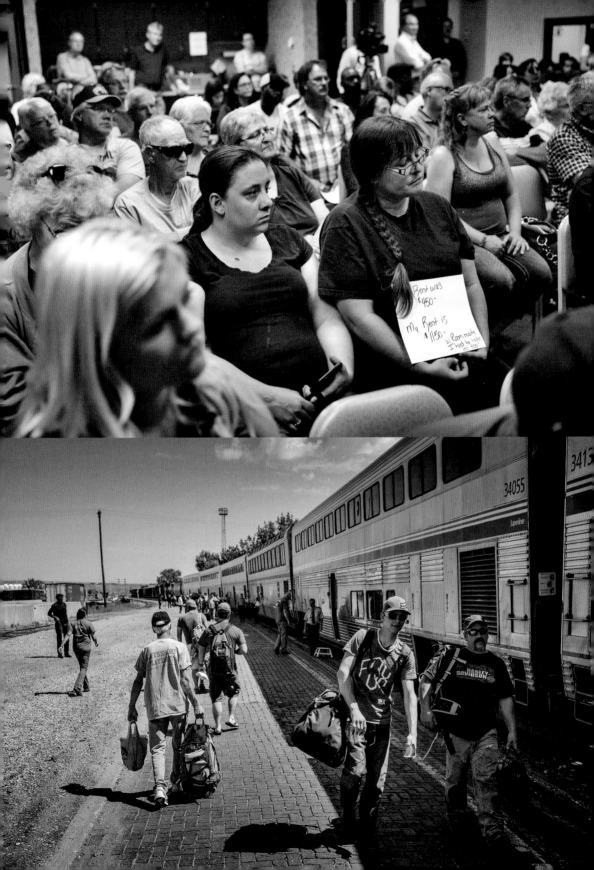

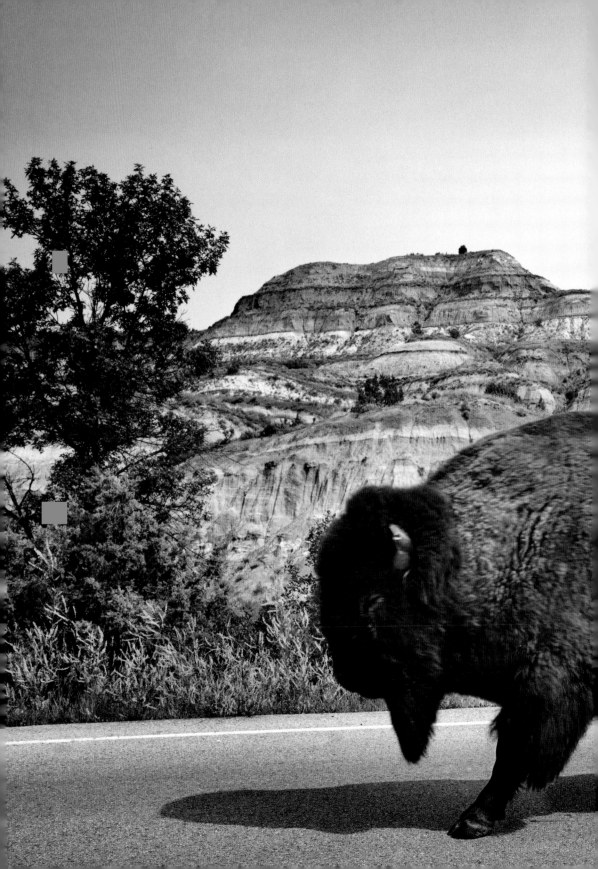

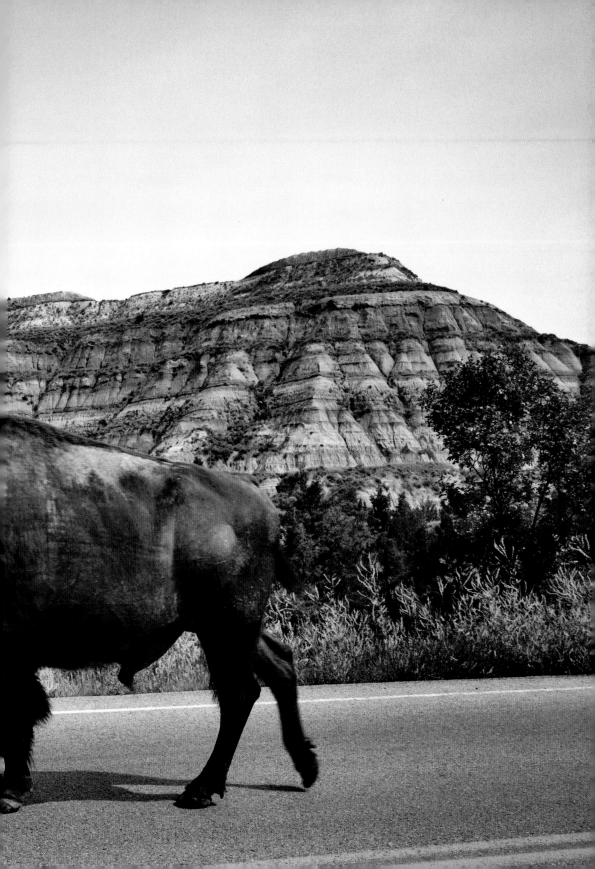

Mirror, Mirror
on the Wall

Émilie Régnier

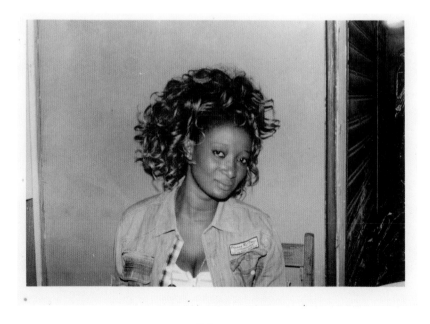

Unknown

Hairstyle is a means of expression. In Côte d'Ivoire, many women put considerable effort into becoming a *go-choc* (a 'babe', or good-looking young woman who makes an impact). As a *go-choc* walks by, men turn their heads. At bars, she drinks champagne and accepts only the company of the rich and powerful. Penniless young men dream of the day when they are older and can afford to take out a *go-choc*. For their part, young women do not skimp on making themselves look beautiful. Many spend their salaries and savings on pedicures and manicures, depigmentation products and especially wigs. Hairstyle is a major feature of a *go-choc*'s image: blonde, red, or black; highlights, extensions, natural, or synthetic.

My aim was to demystify the direct African-American influence on style— a result of globalization, and of images seen on television—and to look at African interpretations. Almost all the women I interviewed about their taste in hairstyle told me that they wished to look like Beyoncé or Rihanna, and sometimes both at once. But the result of their efforts is very individual. To illustrate it, I used a technique followed by local photographers. Unable to afford digital cameras, many Ivorian photographers still work with film. Those who sell their work to hairdressers for illustration purposes, will—to save money when they process the film—place two perspectives of the same hairstyle on each print.

I chose to focus on this subject because I understand what the women are seeking to express through their hairstyles. Image is an inherent part of our identity, and our image is defined by our attitude, our clothes, and most of all our hair. In the Bible, Delilah cuts Samson's hair and he instantly loses his legendary strength. That metaphor still applies today, at least to black women for whom hairstyle and power go hand-in-hand.

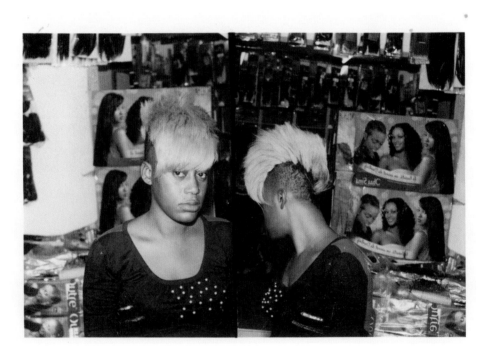

Annie Camara

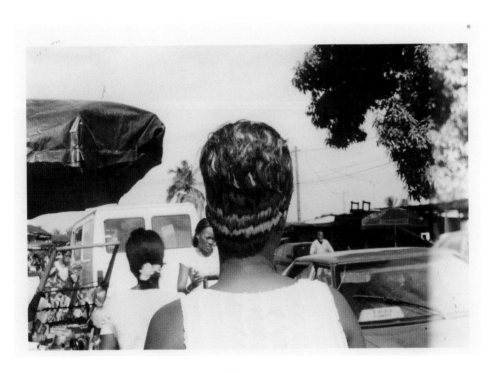

Unknown

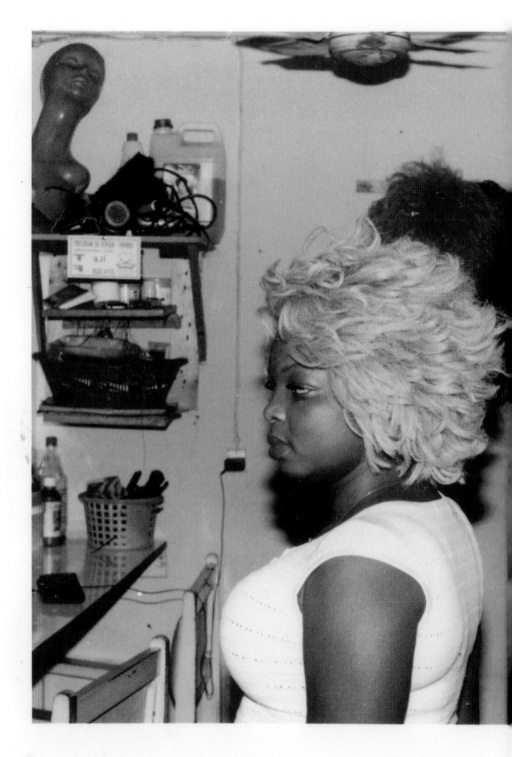

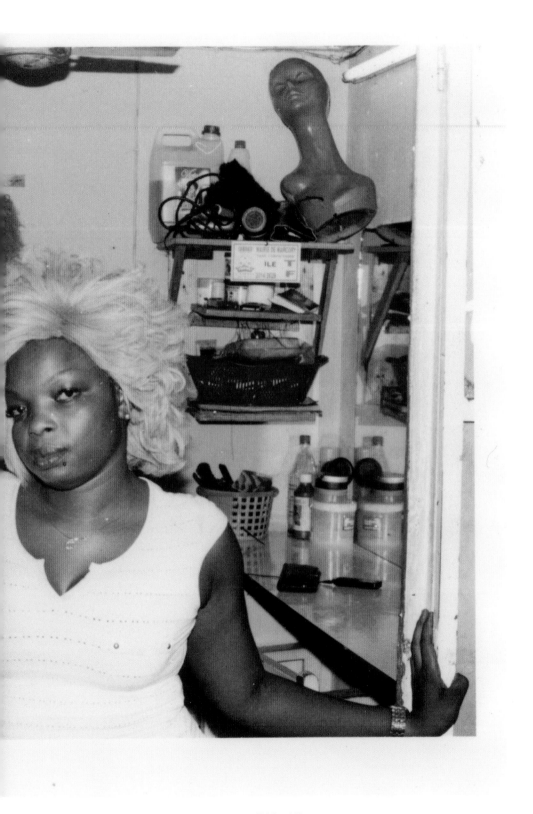

Brigitte Adjoua

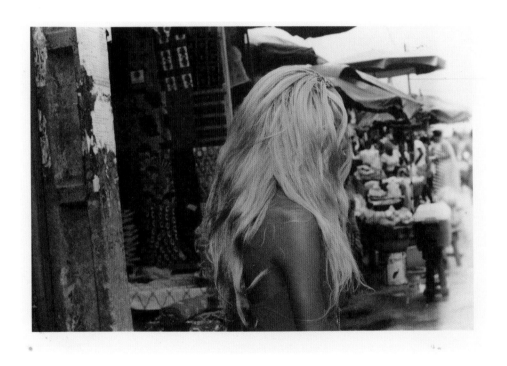

Unknown

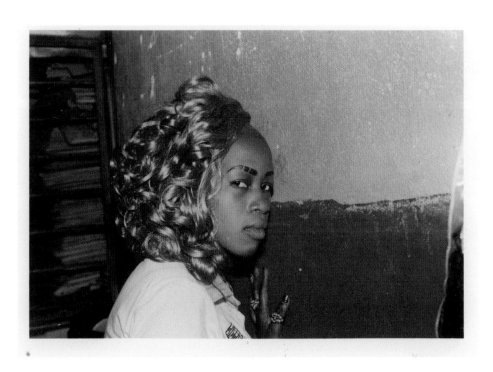

Abiba Yalupé

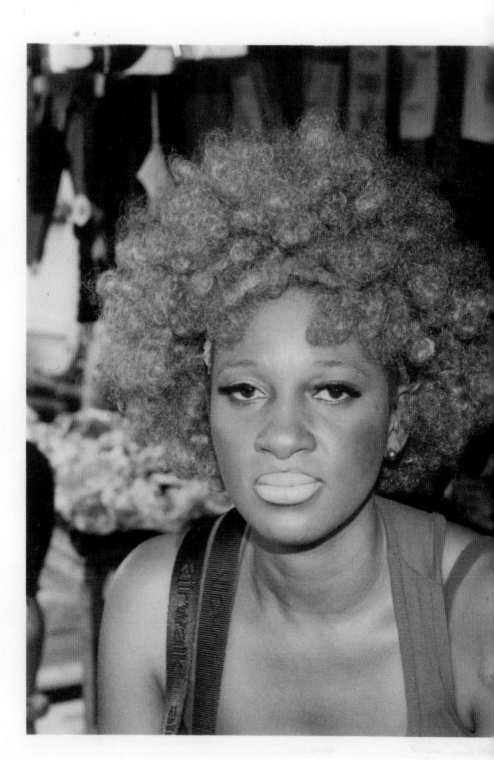

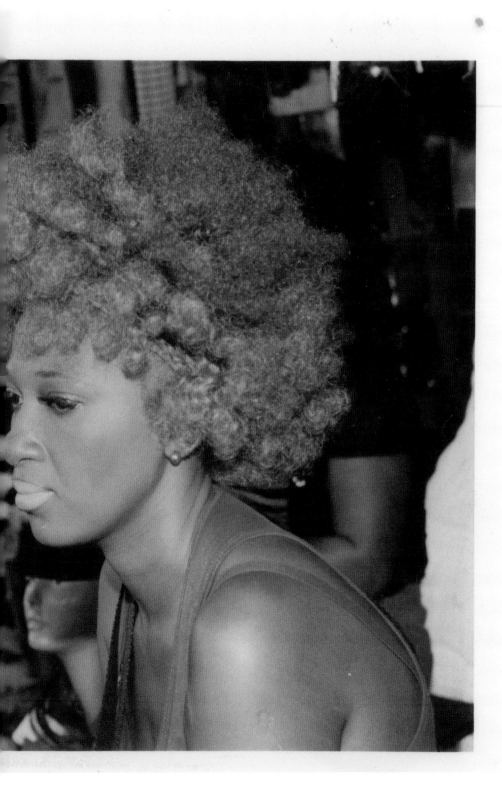

Djata Touré

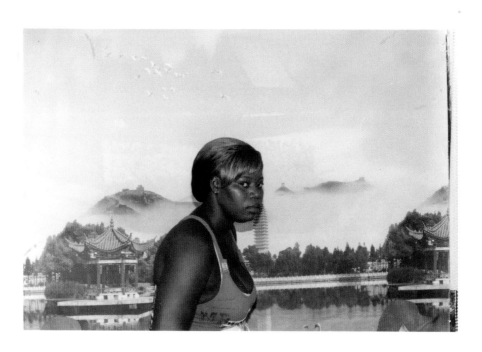

Stephanie Ledjou

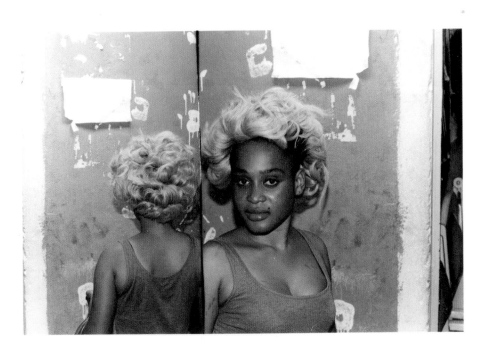

Mariam Sidibé

Pálinkaland

Akos Stiller

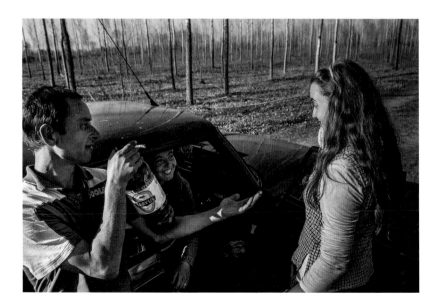

Tamara teases her sister's boyfriend, telling him to find her a good partner. The Kis sisters' mother divorced their father because of his alcohol problems, and has concerns about her daughters' choices in men.

From the shots of the fruit spirit pálinka, knocked back during traditional pig-slaughtering fests, to the bottle of Tokay placed on the Christmas table each year after pudding, the drinking of alcohol is deeply rooted in Hungarian culture. Many see it as part of our national heritage—the Hungarian government has campaigned at a European level for distillation of pálinka for personal use to be tax exempt. But alongside these traditions and the responsible enjoyment of alcohol, runs a more worrying strand. Adult Hungarians (those over fifteen years of age) drink the equivalent of 13.3 liters of pure alcohol per year, which ranks with the highest consumption rates in Europe. Hungary records the highest rate of alcohol-attributable cancer and cirrhosis of the liver in the world.

Drinking wine mixed with cola, together with friends after school, was one of the first steps of rebellion within my age-group. As teenagers, we considered getting drunk to be fun and a macho thing to do, so we made sport of it. Now, the same friends are competitive about bringing the best wines to a dinner party—quality comes before quantity, but all that's happened is that we've grown up a little. I had always had the idea that Nordic countries were the greatest consumers of alcohol. Or the Irish. Or the Russians. Certainly not my native Hungarians. Though the evidence was in front of my eyes, the fact somehow remained hidden. Hungary currently has no effective national strategy to counter the high levels of alcohol consumption. When I learned about just how widespread alcoholism in Hungary was, I decided to shoot a story on drinking in all walks of life—from the traditional and social to the lonely and problematic—to draw attention to a truth that many people deny, or do not realize.

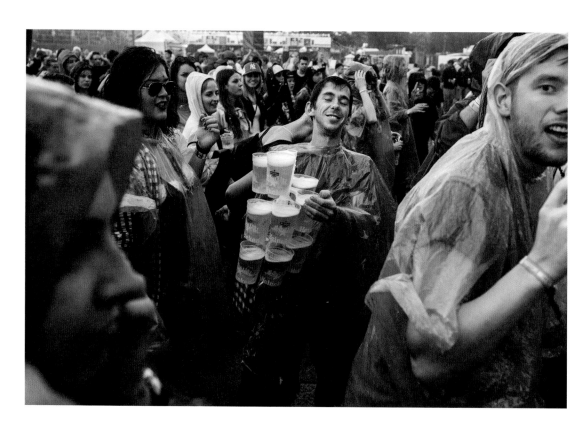

A festival-goer brings beer for his friends at the Balaton Sound festival, in the lakeside town of Zamárdi.

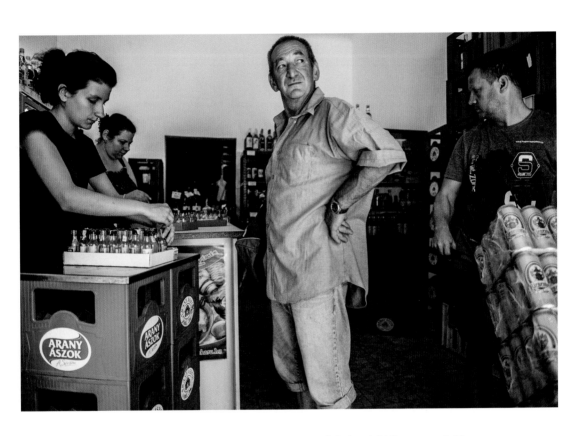

Andras returns empty spirit miniatures to a grocery store in Budapest. A full new one costs 50c. Collecting the deposits on 15 such bottles will fund the purchase. Andras is homeless, and is currently staying with a friend, in return for doing odd jobs around the house.

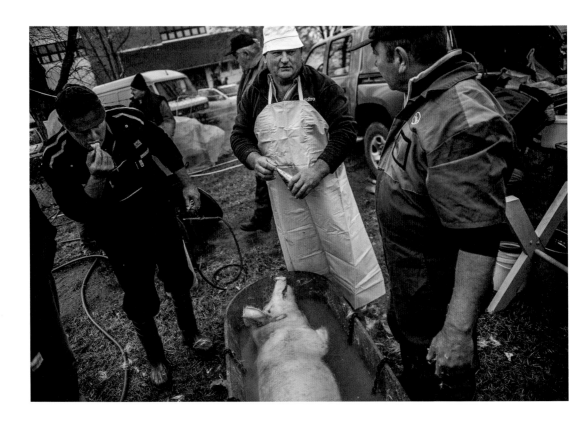

Previous spread: A drunken cyclist rides through woods near Kalocsa, south of Budapest. Hungary used to apply a zero-tolerance law on driving under the influence of alcohol to both motorists and cyclists, but lifted the ban for cyclists in July 2014. Above: Men drink pálinka from a pig's hoof, during a festive pig-butchering in the village of Domaszék, southern Hungary.

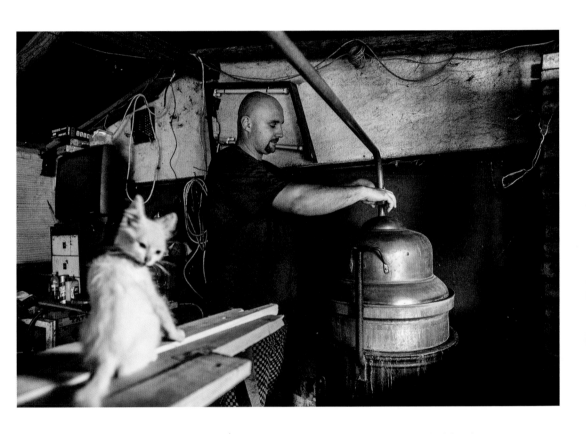

Tibor distils pálinka at home, in Újhartyán, near Budapest. The government defends the rights of citizens to distil the spirit privately.

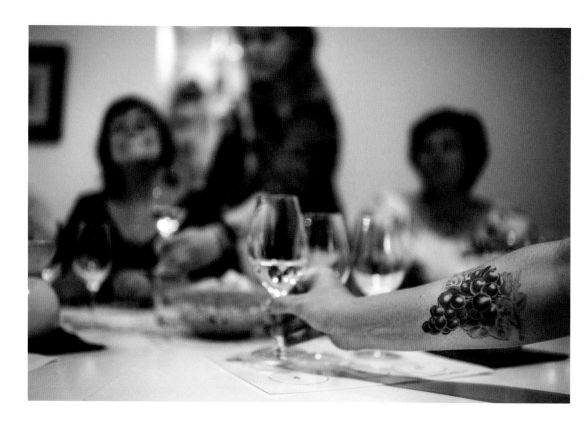

People join in a wine tasting, in Budapest. The history of wine-making in Hungary dates back to Roman times, with sweet Tokay wines being the most renowned.

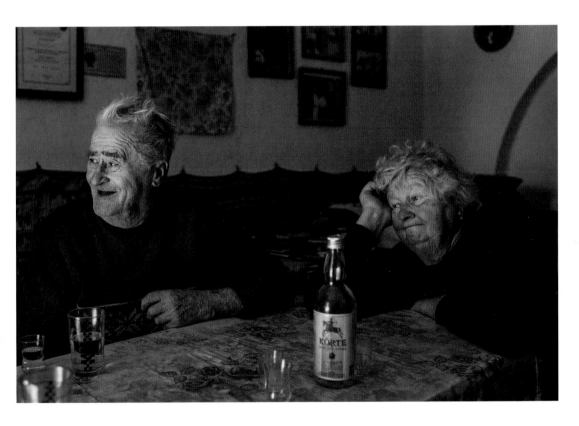

Kató and Pali share a glass or two of pálinka, after a working day. Pali, who is soon to be 80, has survived two husbands, who were heavy drinkers, and now lives happily with Pali, whose drinking habits are more moderate.

Steve shouts "I will be sober," as he is made to come face-to-face with other attendees of the Leo Amici drug and alcohol rehabilitation center in Komlo, southern Hungary, during a therapy session. Steve came to the center to tackle his alcohol problems, after he had been fired from his job, and had his wallet stolen, having passed out for three days.

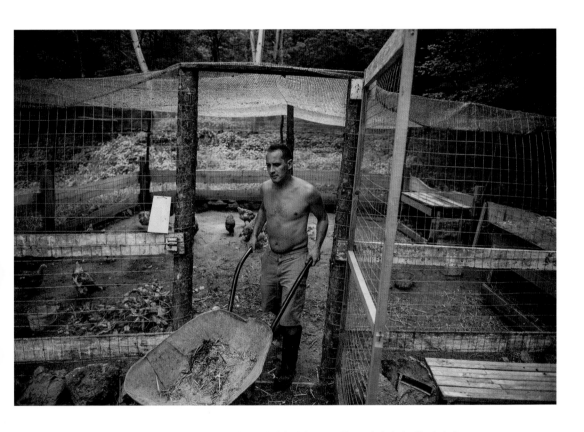

Mihaly cleans the chicken coop at the Leo Amici rehab center. He sought help for his alcoholism at the center after his wife had abandoned him.

'Irresistible' means something powerful, captivating, provocative, urgent. A necessity.

Two-Spirited

Ilona Szwarc

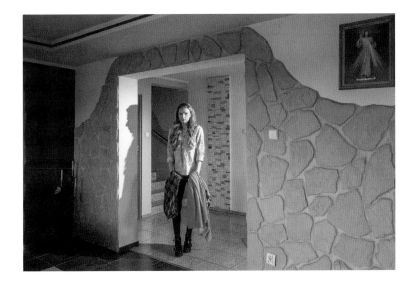

Diana, Gora

Two-Spirited is a series of portraits of transgender women in Poland.In recent years, transgender women have actively been seeking a public platform and are openly talking about their rights. This is largely the result of the national parliament welcoming its first transgender delegate: Anna Grodzka, who was born a man, underwent a sex-reassignment treatment in 2009, and became a member of parliament in 2011. Her election reflects a profound social change in a traditionally Roman Catholic country, and has initiated a significant increase in awareness of the LGBT (Lesbian, Gay, Bisexual and Transgender) community in Polish society.

Through my work, I am interested in asking questions about contemporary definitions of femininity. The position of transgender women in Poland attracted me, because I felt it to be an important subject, and one that talked about an authentic contemporary societal change. As I interviewed the women I was photographing, I came to realize that for them undergoing sex-reassignment treatment was an absolute necessity. No matter how hard they tried, they could not continue to live as men; they could not continue to deny the feminine persona that was trapped in an alienated and often despised male body. Becoming a woman was a matter of surviving. The drive to do so was irresistible.

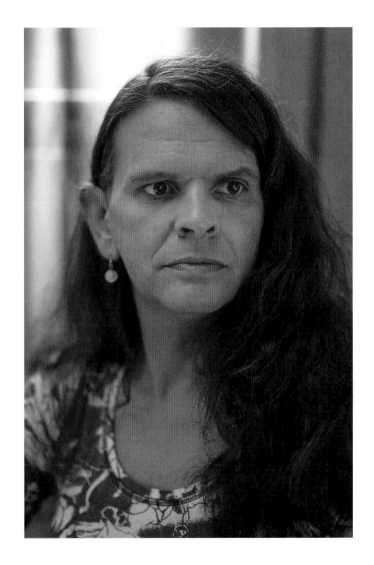

Patrycja, Krakow

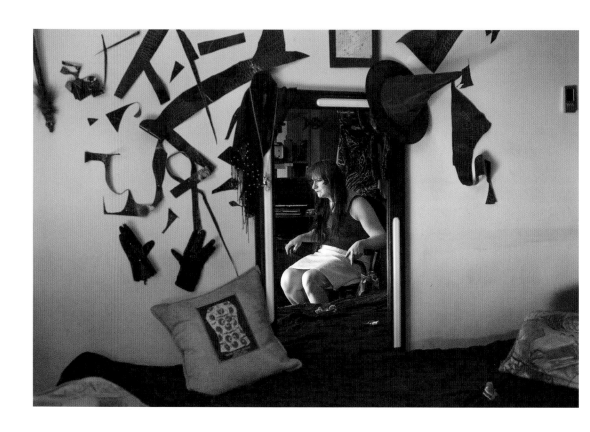

Sabina, Bialystok

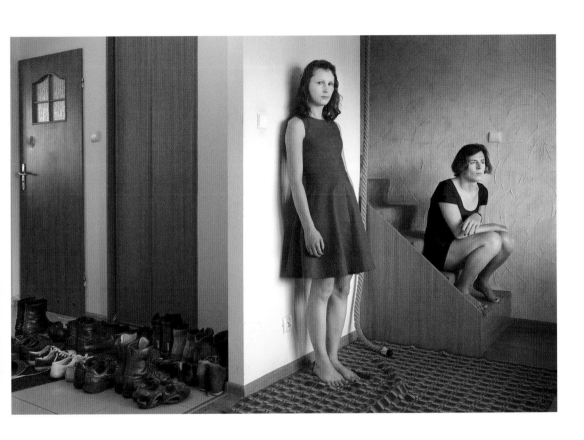

Alicja and Tamara, Grodzisk Mazowiecki

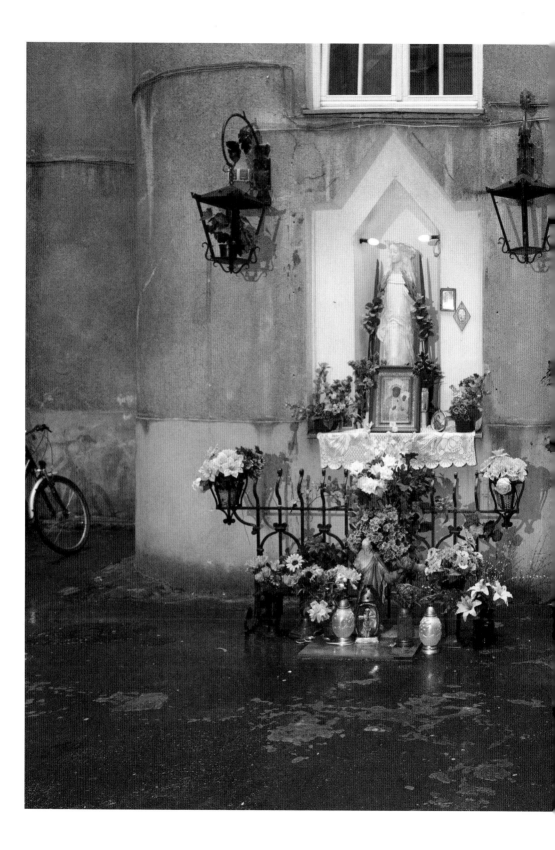

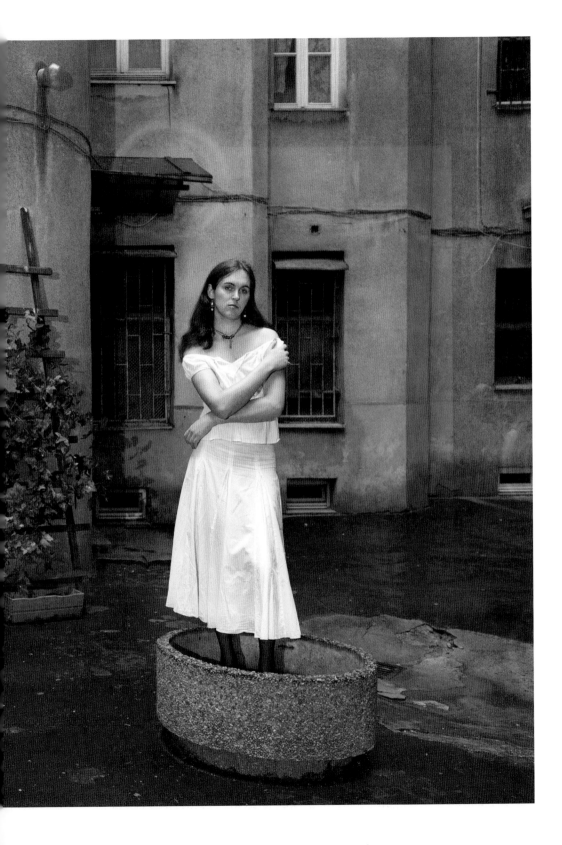

Previous spread: Zuza, Warsaw
Above: Alicja, Grodzisk Mazowiecki

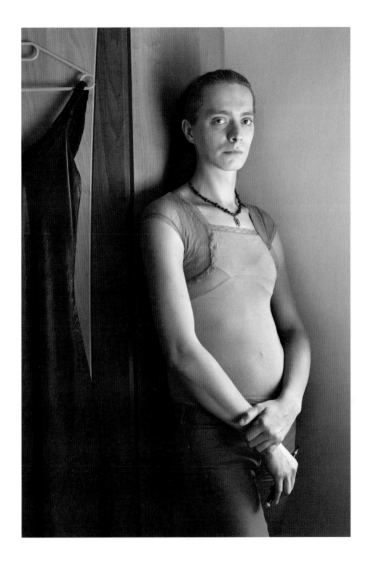

Paula, Krakow

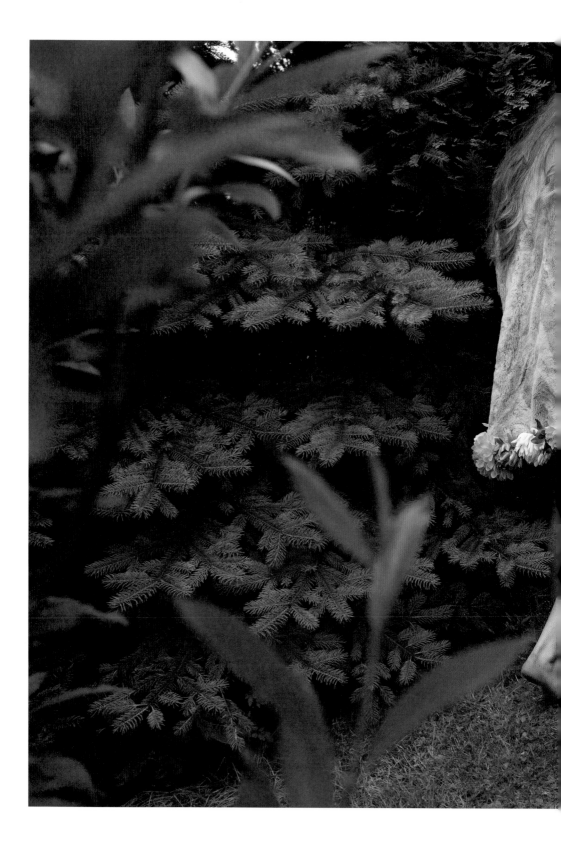

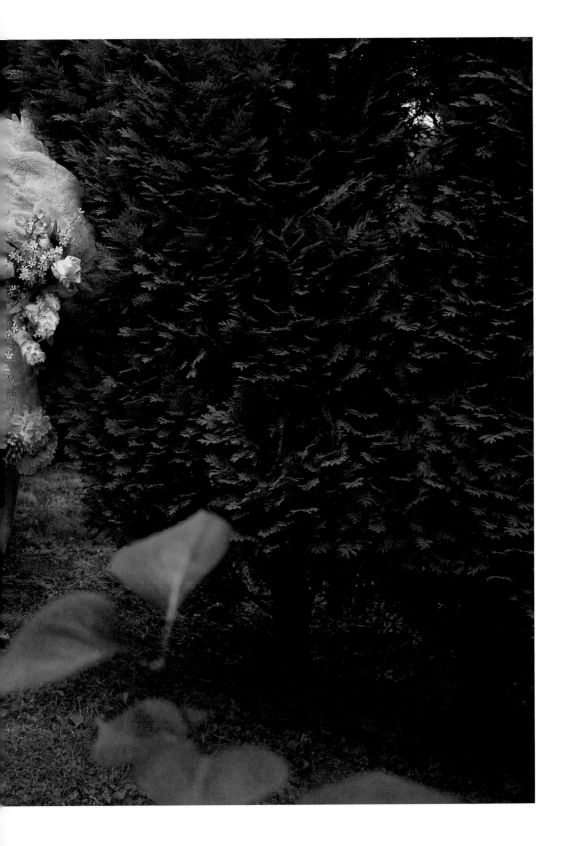

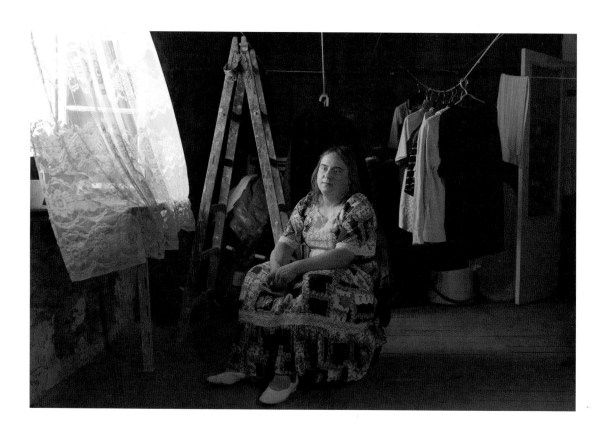

Previous spread: Diana, Gora
Above: Marysia, Strzelin

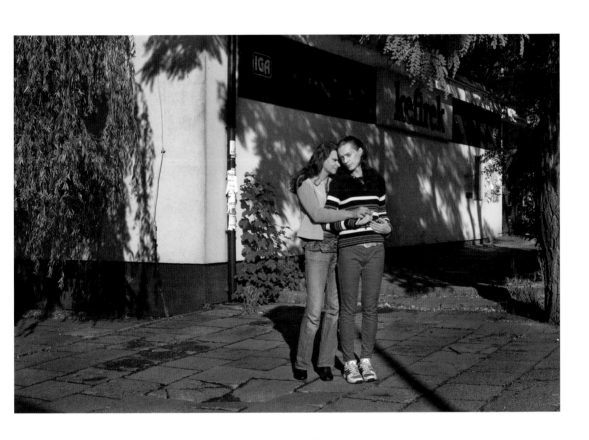

Patrycja and Paula, Krakow

Fading
Frames

Giorgio Di Noto

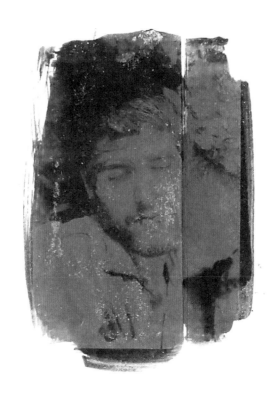

Every day we encounter hundreds of images. At one end of the spectrum are those that contribute to our collective unconscious; on the other are those that disappear from our memories a second after we have seen them. We experience these countless images without controlling what our memory records, what it withholds, or what it removes immediately. This is a compelling process of perception and memory: we can't resist seeing the images, we can't resist forgetting them.

With this project, I wanted to find a visual representation for this process—to research the relationship between an image itself, how we are attracted to and elaborate it, and memory. I wanted to examine how photographs work and can tell us something, how we experience the hundreds of images we see every day. And I wanted to look at the contrast between the information initially contained in an image, and how our minds process it.

This gave me two problems to solve: what images to use, and what technique to employ to represent the process. I decided to use images in the public domain—images that were visual clichés, which looked like thousands of other pictures. And I decided to portray the mental processes metaphorically, through a darkening procedure. Light both creates and destroys an analogue photograph, both imprints and blackens it, and so is in a sense its own metaphor for something inherent in the process, which is unstoppable and can be destructive. I printed the images using light-sensitive ink on paper, without using chemical fixers. With time, light advances the darkening process, and the once-recognizable images slowly disappear to become indistinguishable stains. Their original information is hidden in the ink. I used Moleskine paper, because the notebooks are objects in which we usually record our thoughts. I liked the contrast between this idea, and the disappearing process of the images. There is a relationship between the means and the content of the project, an attempt to present one as a metaphor for the other.

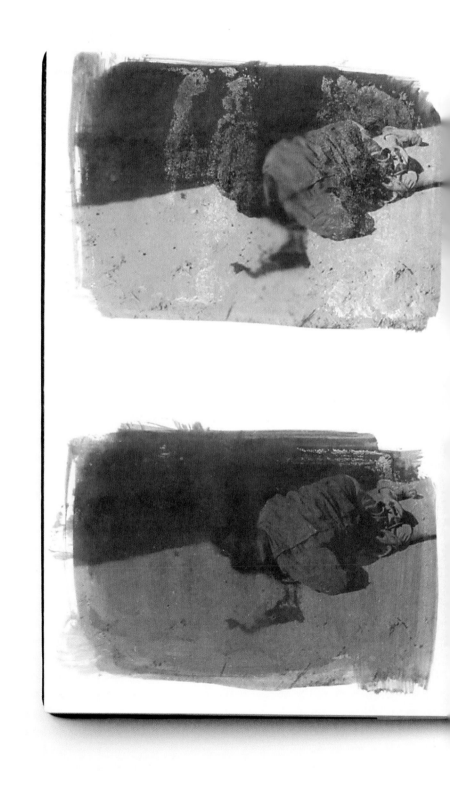

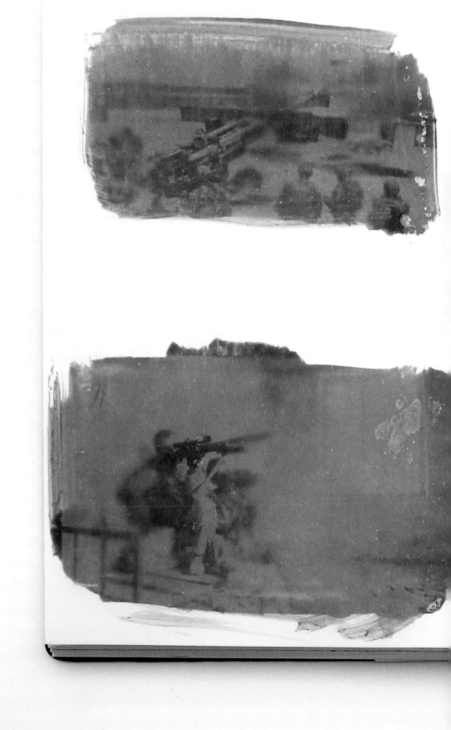

Lust to
the Roots

Meeri Koutaniemi

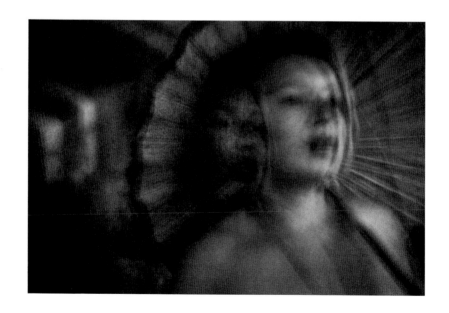

Desire for encounters can constitute a fundamental need. Laura, a single Finnish person, describes her gender and sexual orientation as open-ended entities. My photo essay is a visual diary that follows the path of Laura's mind, observing her inner landscape. Glimpses of nudity and views of nature are combined with visual extracts of urban life. My aim was to build scenarios that everyone can recognize—memories of timelessness, moments of reflection, desire for another's body. After knowing Laura for more than ten years, and having endless discussions with her about sexuality, I became interested in the way our acts and dreams combined to form our identities. I considered Laura's fantasies to be very similar to mine, and we ended up collaborating in friendship, openness and trust. I wanted to get deeper to the roots of her—from memory to dream, and from dream to action.

I think that imagination is at the very core of human sexuality, and that our imaginations grow from our deepest roots, to form a visual, auditory, sensory and experiential database. *Lust to the Roots* stems from my need to understand sexuality as growing from these roots. My photos combine tangible acts and imagined dreams into one reality, where it is difficult to draw the line between concrete and abstract.

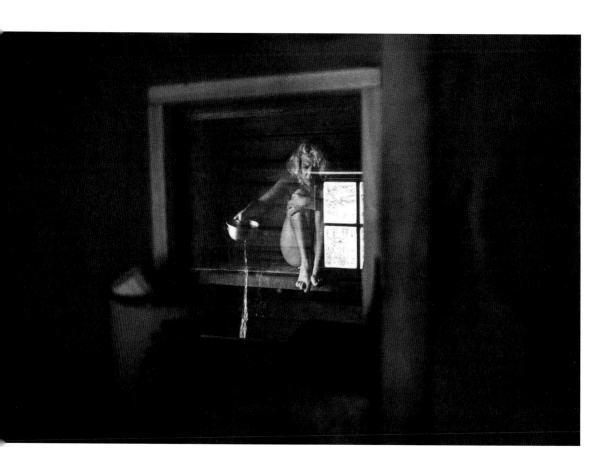

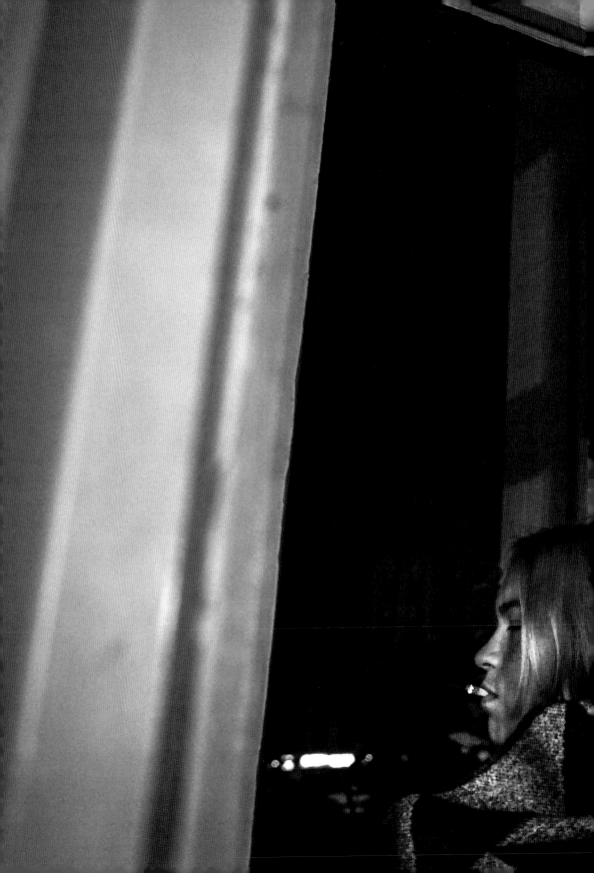

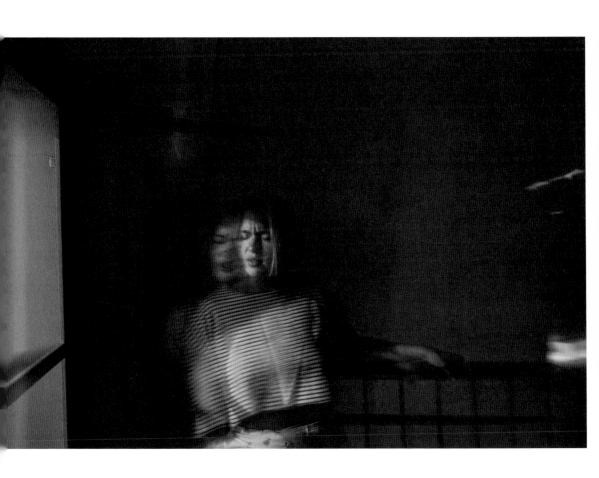

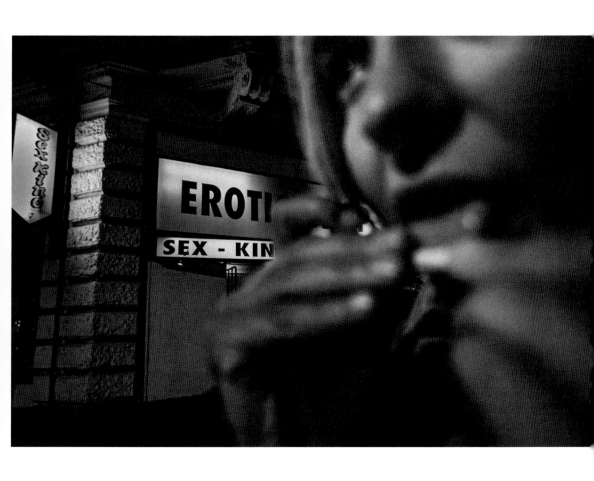

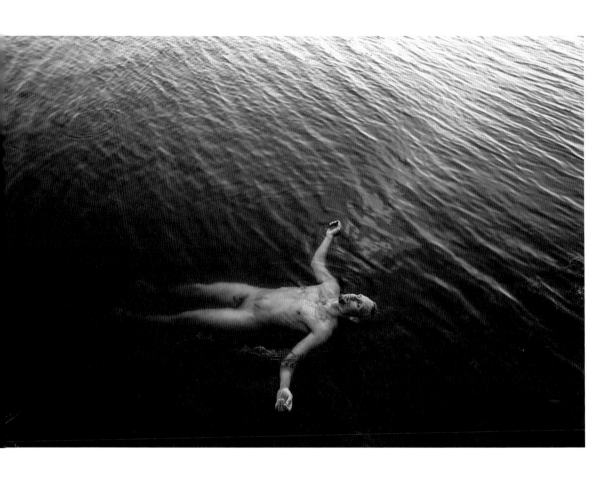

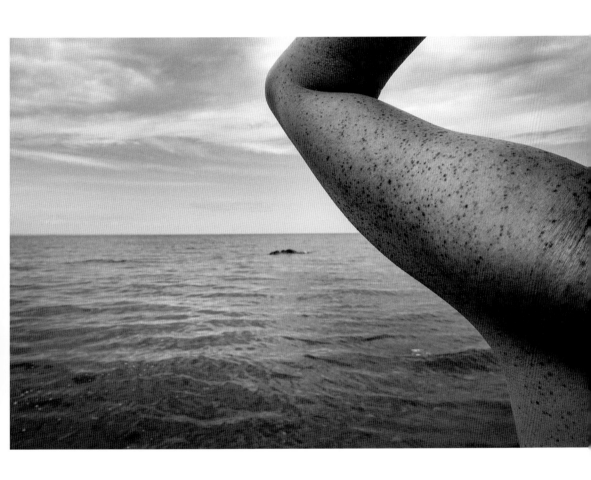

Love Me
or Kill Me

Sarker Protick

The Bangladeshi film industry—based in Dhaka, and so known as 'Dhally-wood'—has been going since 1956. Dhallywood movies have fallen out of favor among the richer classes, who prefer foreign films, and the growing influence of Bollywood (Hindi cinema) films in Bangladesh has also had an adverse impact on the local industry. Yet the Dhallywood industry produces around 100 movies a year, and does still enjoy the support of many ordinary movie-goers.

'Love Me or Kill Me' is the title of a Dhallywood film, one that expresses the extreme emotions that define the genre. Love and revenge are the core ingredients of our movies. The stories do not change much: boy meets girl, boy falls in love with girl, bad guy takes girl away, hero fights to get her back. There is always the same climax and a happy ending. The events and details are odd, sometimes weird. The costumes are flashy, the sets and effects are cheap, and the colors are daring. There seems little or no contact with reality. But people love it.

When I was growing up in Dhaka, there was no television except the national channel. Going to see a Bangla film was for us the height of entertainment. Slowly, other films and TV channels took over. We didn't think Dhallywood movies were cool anymore; they no longer played a part in my life. Originally, when planning this project, I'd intended to shoot a story on the city where I grew up, and thought of including a single shot of a film set in the sequence. I visited a studio, and was captivated by the colors, by the light, by the atmosphere. My experience there on the first day changed my mind about a focus for the project. Shooting a story on Dhallywood became irresistible.

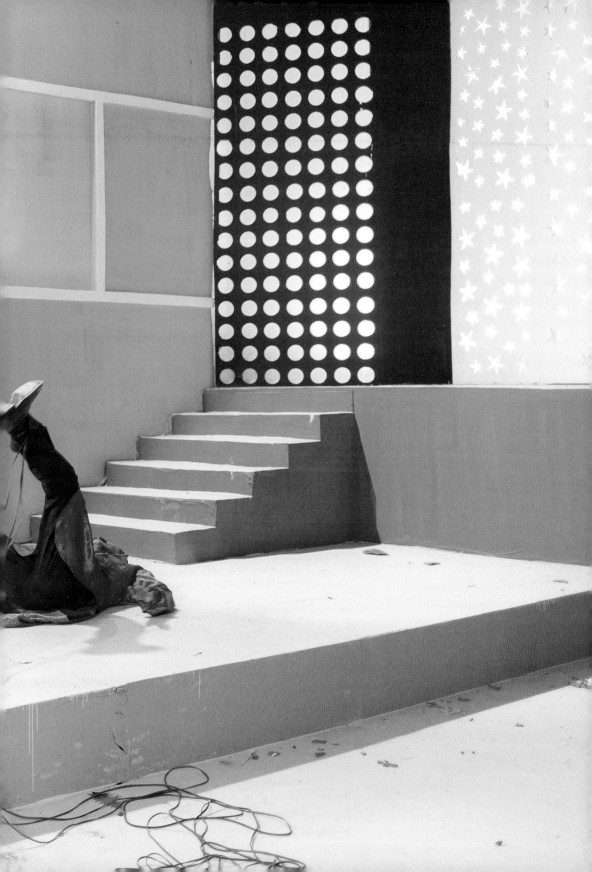

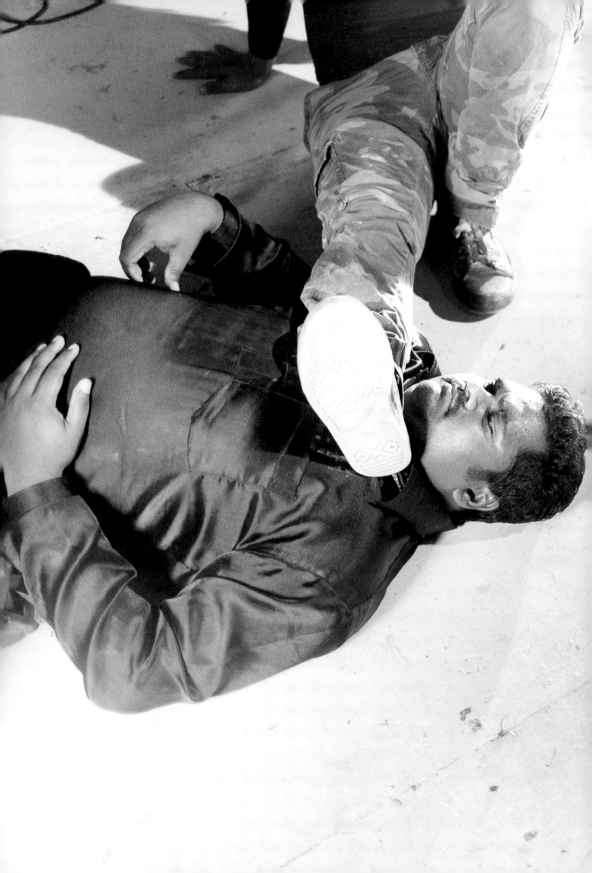

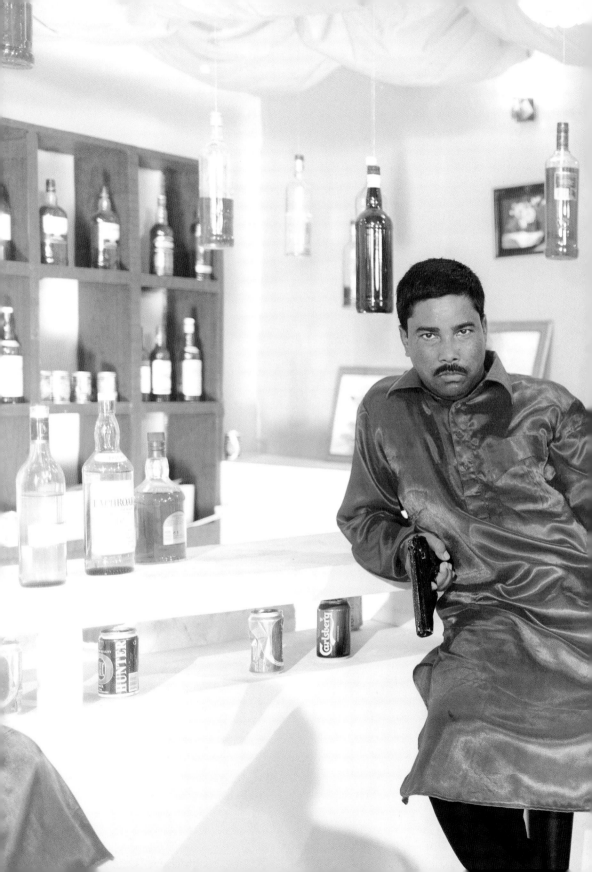

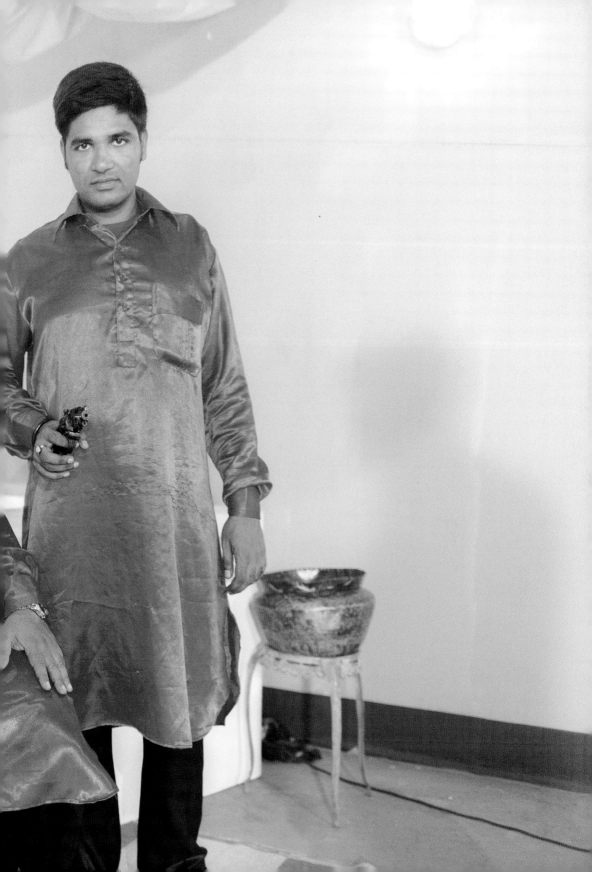

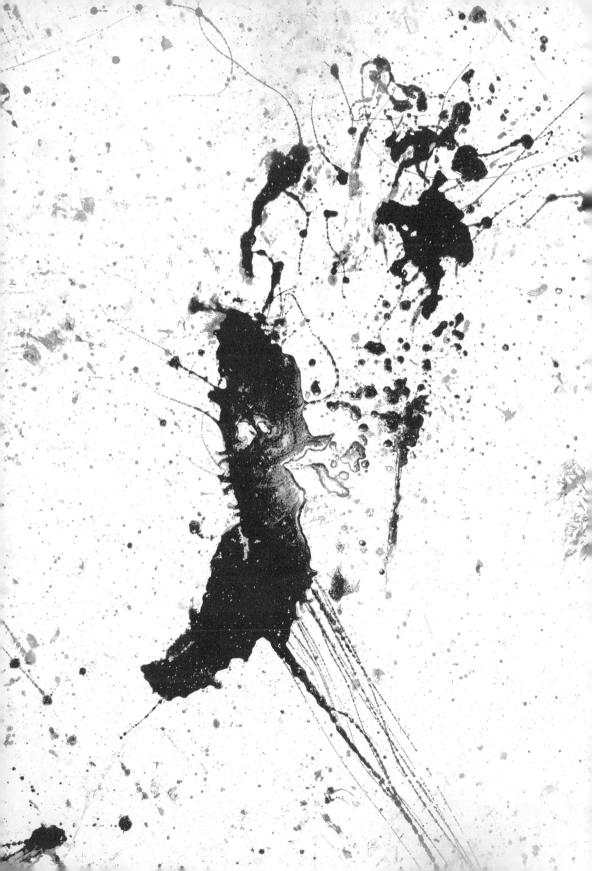

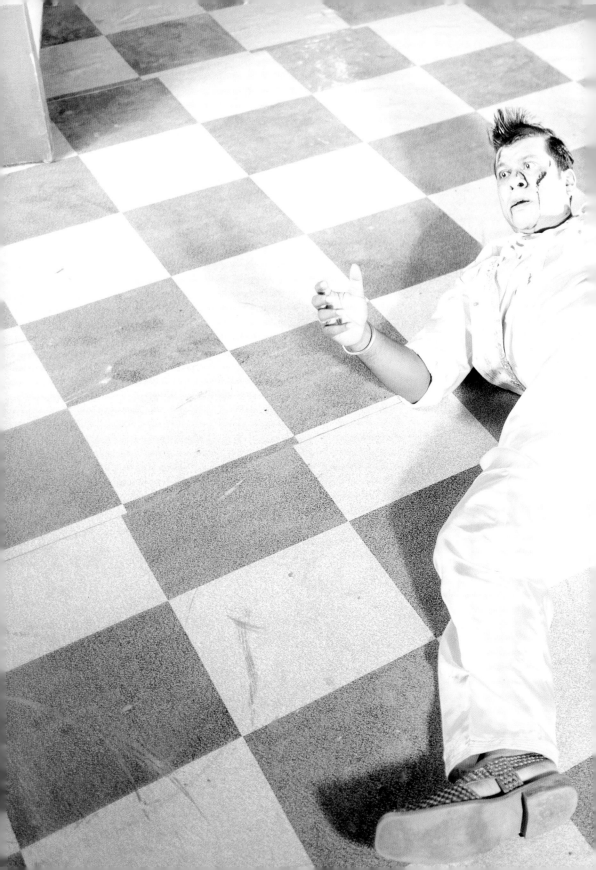

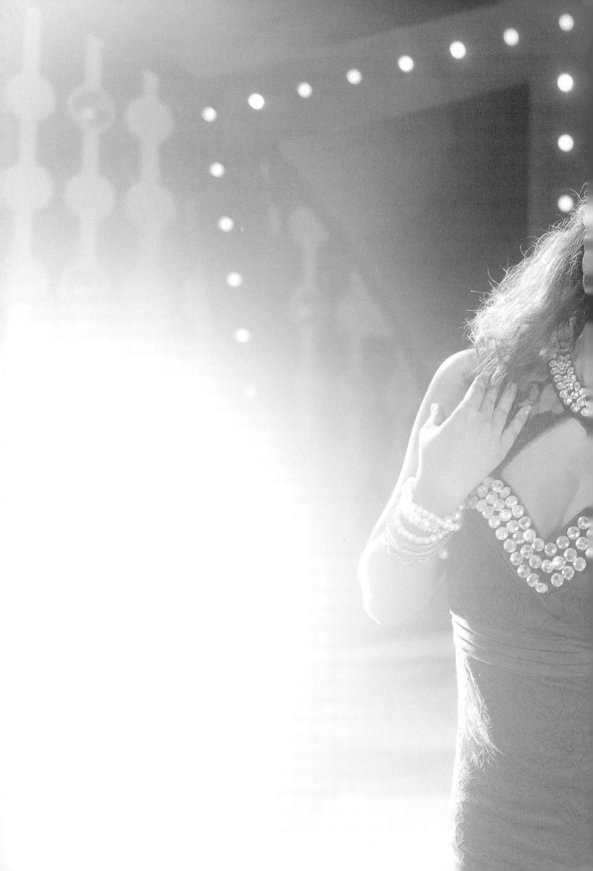

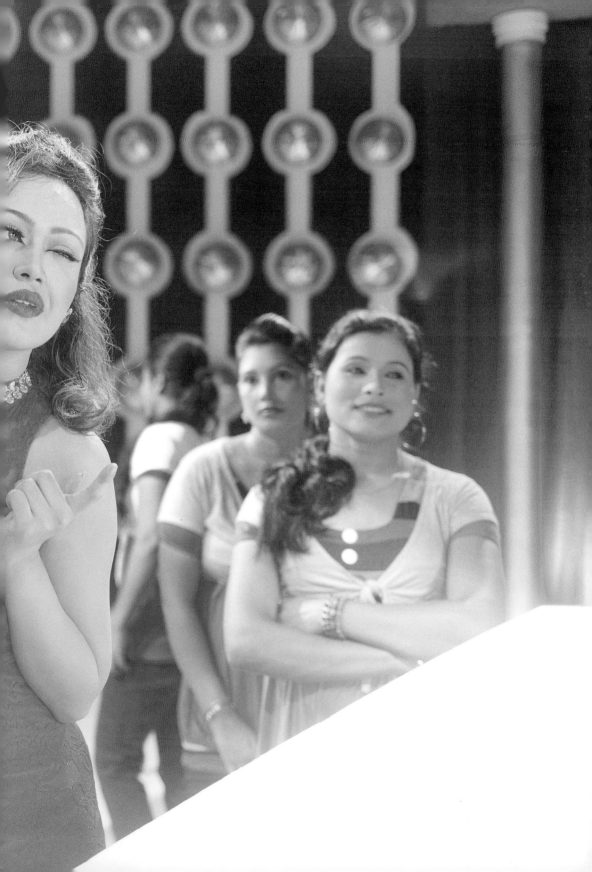

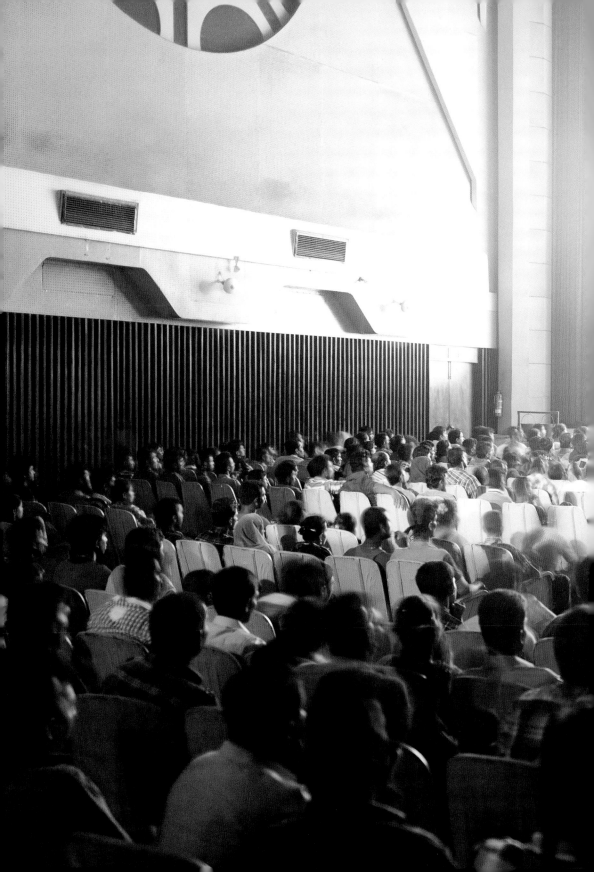

Ugly Mugly

Bego Antón

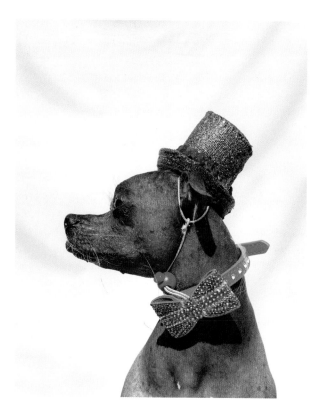

Mugly, the 'ugliest dog in the world'. His owner, Bev, likes to dress him up
and works with him to raise money for dog rescue centers in the UK.

Bev Nicholson's dog Mugly was declared Britain's Ugliest Dog by a national newspaper in 2005, and in 2012 won the World's Ugliest Dog Contest in California. Mugly, a ten-year-old hairless Chinese Crested dog, has further claims to fame—he works as a therapy dog, helps raise money for charity, has made numerous media appearances, and has over 4,300 Likes on Facebook. Chinese Crested dogs come in two varieties, often born into the same litter: hairless (with tufts on the head, paws and tail), and powder-puff (covered in thick, long hair). But, even by Chinese Crested standards, Mugly is bald. Despite that, Bev adores him, Mugly howls inconsolably whenever Bev leaves the house, and she says she feels awful if she has to leave him even for a couple of hours. Bev has five other dogs (all, like Mugly, from a dog rescue center, and bearing names beginning with M). She loves dressing them up, mostly because the hairless ones get cold in winter, and burnt by the sun.

I'm fascinated by the bonds we create with our pets, and especially by the way we anthropomorphize them. More generally, I'm interested in the bonds humans form with other species, and with the contradictions these relationships sometimes involve. I thought that doing a project on Bev and Mugly might highlight one aspect of these contradictions. *Ugly Mugly* is a reflection on how we relate to our pets, and how what is close and important to us can change our perceptions of qualities such as beauty. Bev feels devotion to Mugly even if he is ugly, stubby and has only one lock of hair growing from his back. The truth is that she doesn't find him ugly at all.

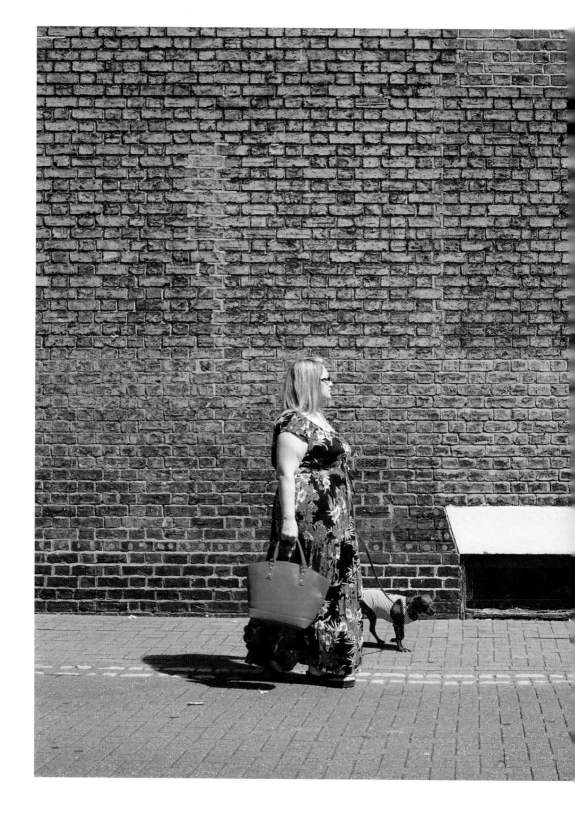

Bev takes Mugly for a walk. He is the favorite of her six dogs, and he takes him nearly everywhere she goes.

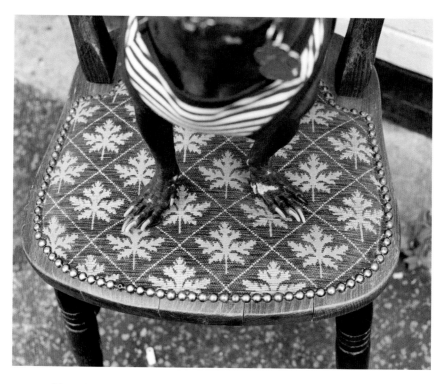

Chinese Crested dogs have particularly elongated toes. The nails cannot be cut too short, as this causes pain and bleeding.

Mugly often receives letters and gifts from fans around the world.

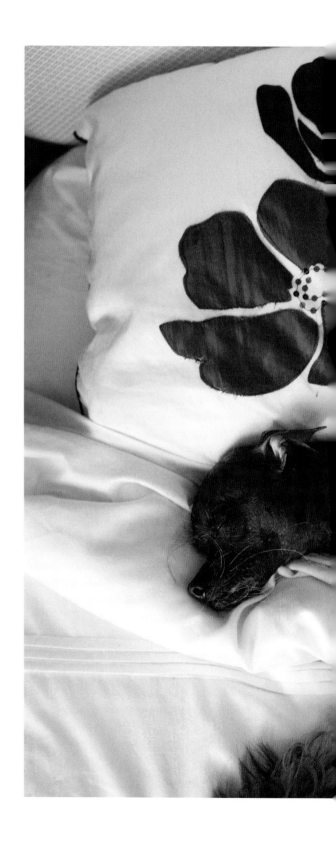

Mugly sleeps on Bev's bed every night.
They are rarely apart.

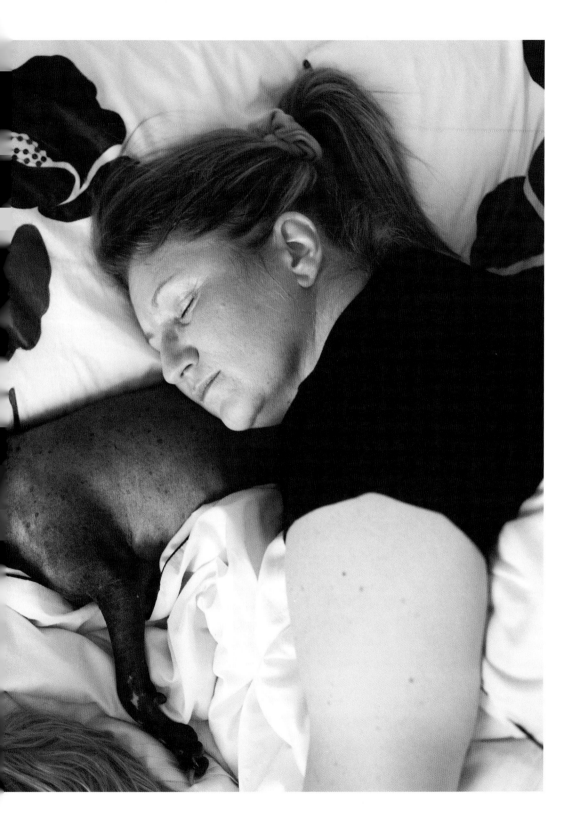

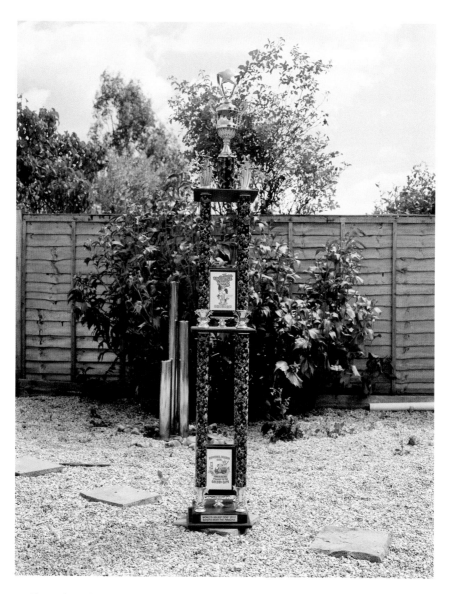

The trophy Mugly won in California for being 'The Ugliest Dog in the World' is almost two meters high.

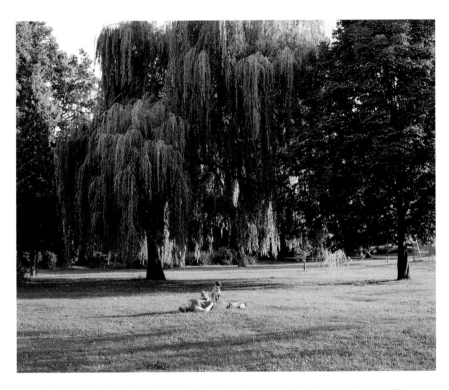

Bev, Mugly, and another of Bev's dogs, Millie, rest in a park. Bev finds it difficult to walk all of her six dogs at once, so takes them out separately, at different times of the day.

Bev owns a wide range of small fancy-dress outfits, which she has bought especially to clothe her dogs.

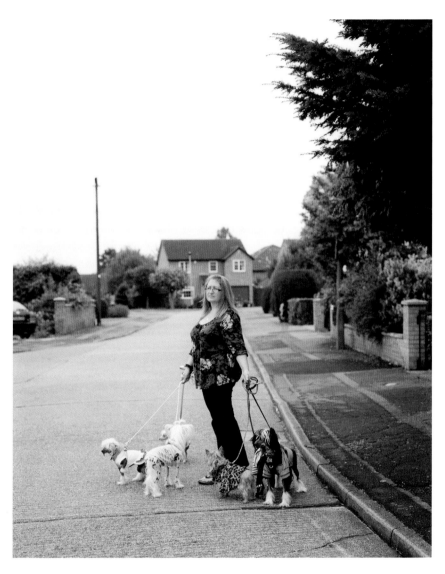

Bev gets ready to cross the street, on one of the rare occasions that she takes all of her dogs out for a walk at the same time.

Debbie and Barry

Isadora Kosofsky

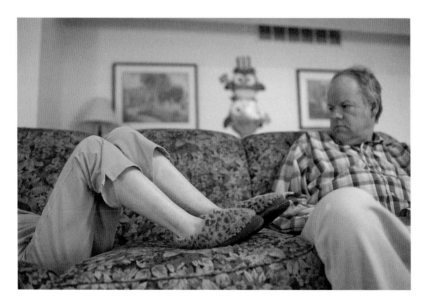

Barry looks across to Debbie, as they relax on her couch in the evening. Sometimes one of them wishes to be alone, while the other desires closeness, but they spend most evenings together in Debbie's living room.

Debbie (49) and Barry (58) live in the Los Angeles Residential Community (LARC) ranch, at the foot of the Saugus Mountains near Los Angeles. The ranch comprises a number of adjacent communal homes for developmentally disabled adults. Of the 65 residents who participate in daily workshop activities, a number have formed strong attachments with each other. They accompany their partners every day, doing tasks and recreational activities designed to keep them engaged and mentally active, or join other residents on organized excursions. A few are married couples, while others–like Debbie and Barry–are in long-term relationships.

Debbie and Barry first met 29 years ago, at a day-care program in the San Fernando Valley, north of Los Angeles. As young adults, they sat apart and passed notes to each other during work. Debbie immediately liked Barry because her old boyfriend had held her too tightly, and Barry was gentler and didn't need to be told that she wanted to be held. Barry was attracted to Debbie because she was a new face that he wanted to know. When, some two decades later, Barry's mother decided to place him at LARC ranch, Debbie asked her family to let her live there, too, in order to be with him.

Debbie and Barry refrain from physical contact in the LARC workshop, so as to remain private. At night, they return to their house and sit together in Debbie's living room. In both the public workshop and private setting of the home, Debbie and Barry are often in conflict over misunderstandings and distractions. Sometimes, Debbie finds it a challenge to express herself verbally, and she becomes frustrated when she feels that Barry's lack of focus means he's not listening. Barry expresses feelings of powerlessness when Debbie becomes emotional, and he is unable to fix the situation. Nevertheless, regardless of the circumstance, the day usually ends with Debbie tapping Barry on the arm and saying "I love you," and Barry confirming that Debbie is "the only one for me."

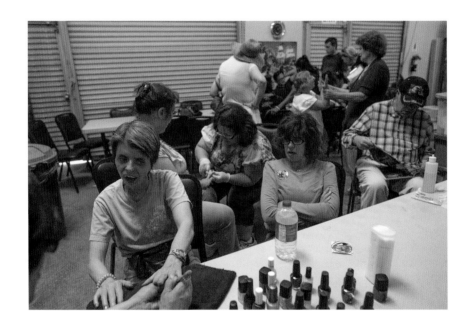

Debbie gets her nails done, in a room off the communal workshop, while Barry sits nearby reading *National Geographic*. Most of their day is spent in communal activities.

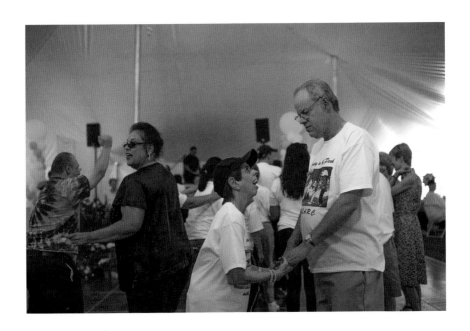

Barry and Debbie dance at an annual ranch social event. They are part of an older generation of residents at the ranch, and are normally reticent about expressing their affection in public, passing comment on the younger people who do so.

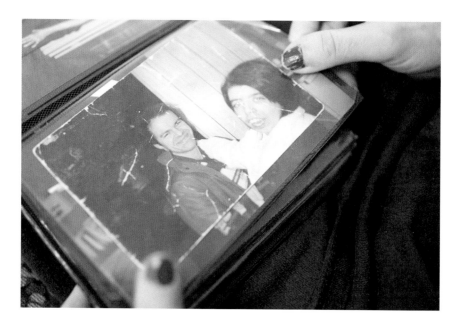

Debbie looks at a photograph of herself, aged 22, and Barry, who was then 30, a few years after they first met.

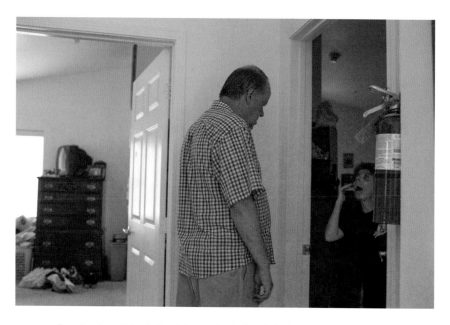

Barry knocks on Debbie's door, but she tells him that she is tired and wants to be alone.

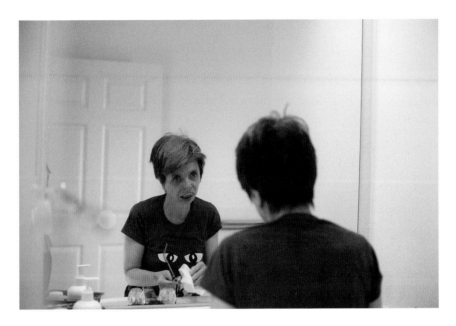

Debbie cries as she cleans her glasses in the bathroom, frustrated because Barry hasn't responded to her expressions of affection.

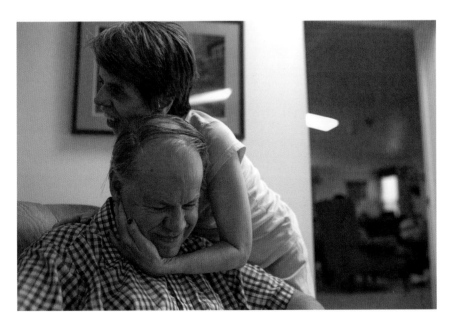

Debbie embraces Barry in her living room. Embracing, and being held gently, is especially important to her, something she feels that Barry understood from the beginning of their relationship.

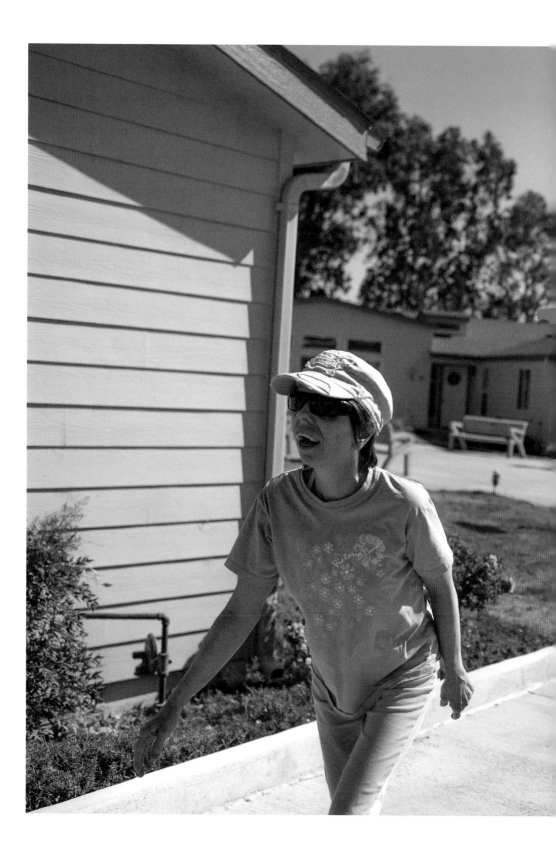

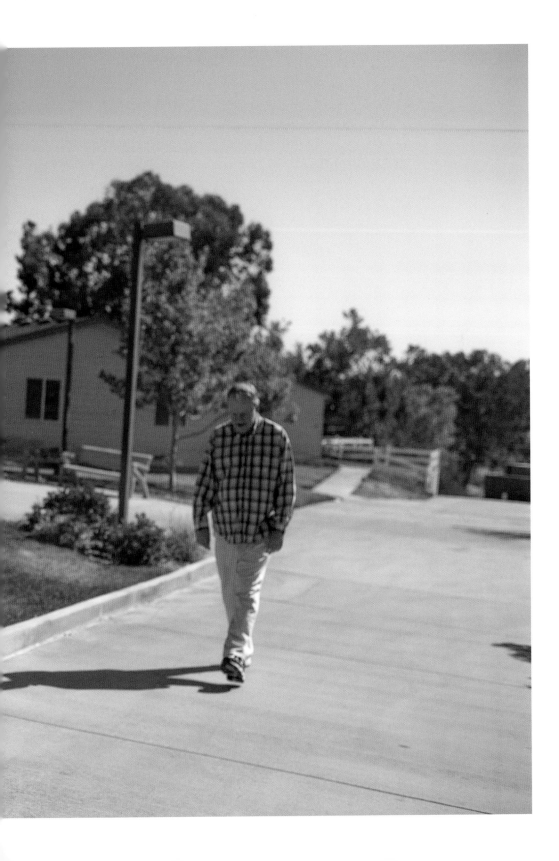

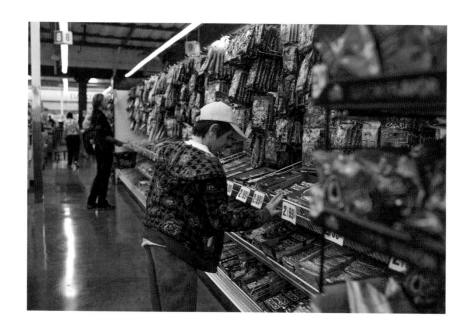

Previous spread: Debbie walks to the recreational building at the ranch, with Barry coming up behind.
Above: Debbie examines her favorite candies, choosing which to buy, during a weekly outing to
a bargain store.

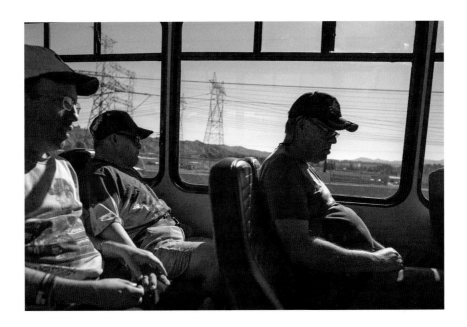

Barry sits on the bus, on the way to a barbeque lunch in the park. The staff accompany ranch residents
a number of times a week, on shopping trips, and on visits to outdoor spaces and restaurants.

Shooting Stars

Andrejs Strokins

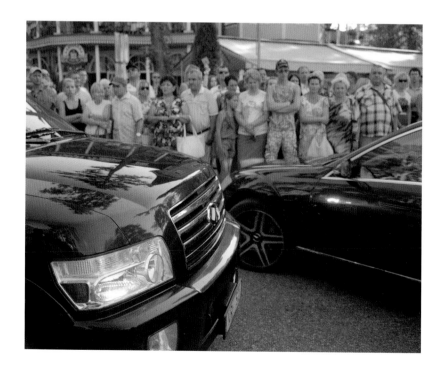

Jānis Ogle works as a reporter for *Vakara Ziņas*, a weekly tabloid magazine. Most of the time, Ogle waits and watches, watches and waits—at events, outside celebrities' homes, at places where they might make an appearance. If he spots something going on, he asks a photographer to take photos, and might try for an interview, or call the celebrity later to find out what was happening, or simply write a caption. Ogle doesn't care for celebrities, or for his job. He does it for the money.

Yet, in a way, Ogle brings glamour into people's lives. Our society follows a cult of celebrity; we adore people simply for being famous. This goes further than just an interest in people's personal lives, it involves a feeling that they are somehow superior, that our lives are small in comparison to theirs. Celebrities can influence what we choose to eat, wear, buy, where we go and what we see. The American media psychologist Stuart Fischoff maintains that this celebrity worship is entrenched in our genes, prompted by a primordial instinct to follow a leader.

I worked with Jānis Ogle for several years, collaborating on celebrity news stories. For this project, I decided to dive back into the world of the tabloid press, in order to explore the situations I had experienced previously from another perspective. I wanted to show the absurdity and boringness of the job. The whole celebrity cult is, I believe, based on myths and lies—yet people want to be entertained. They like to dream, and they are willing to pay money to be supplied with those dreams. The tabloid media business is based on those simple truths.

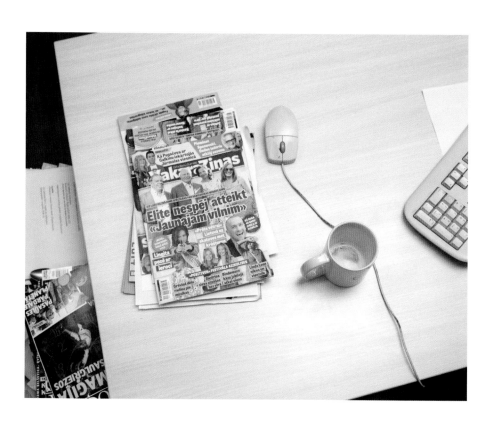

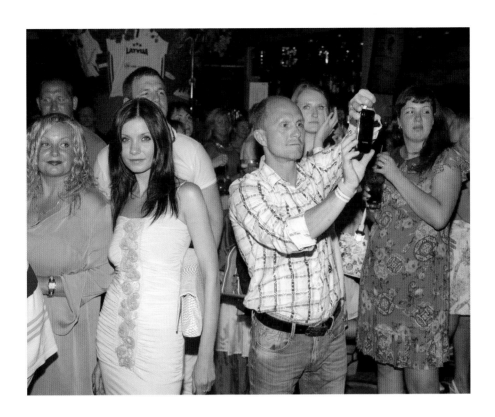

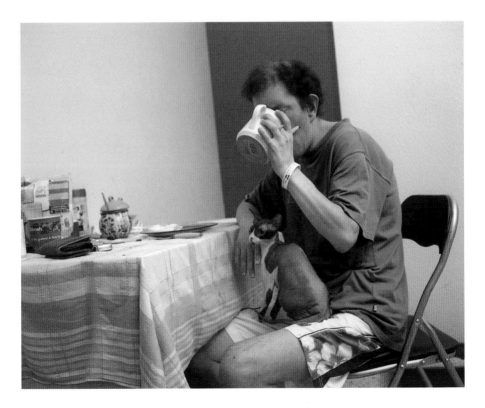

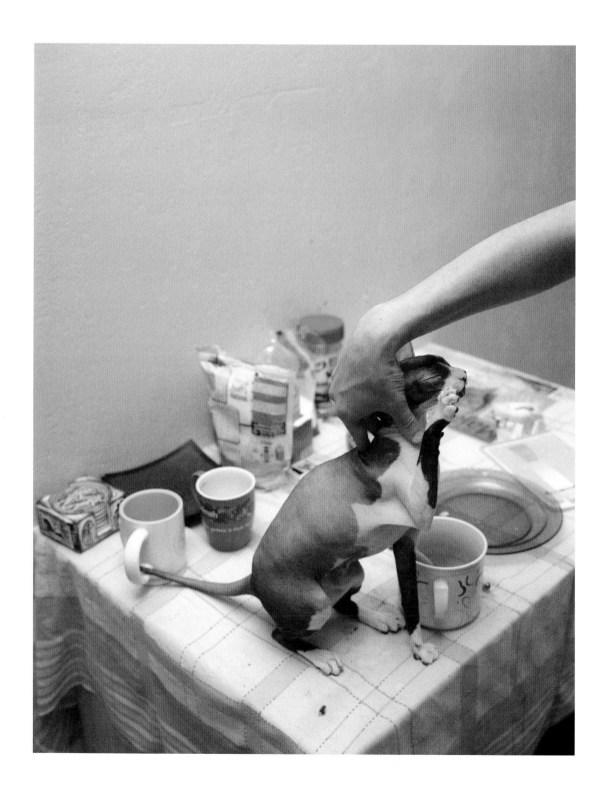

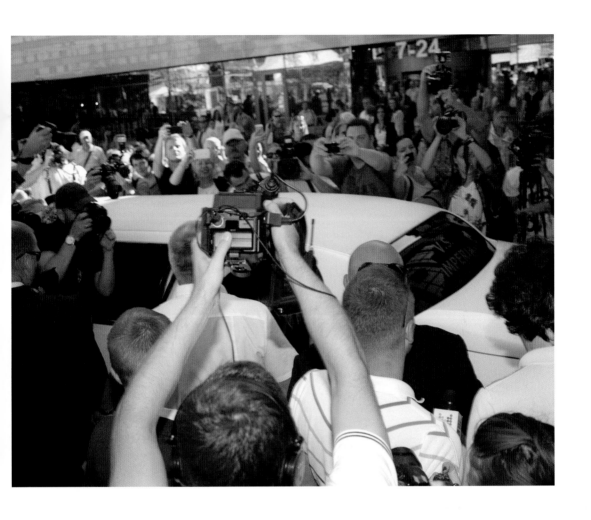

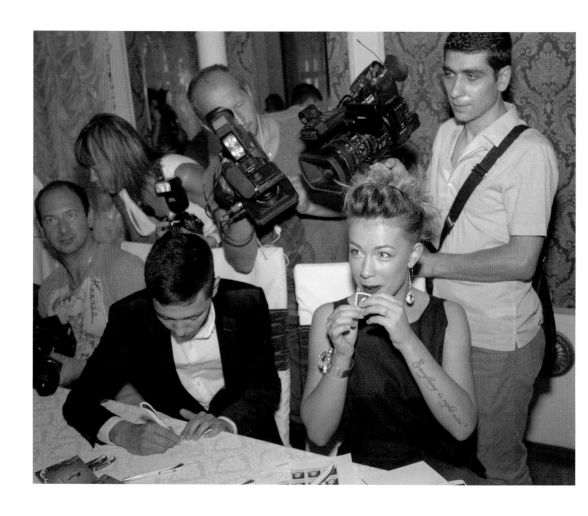

Something that makes you happy in the present, and remorseful later. That's 'irresistible'.

Transmission

Bryan Schutmaat

In a longstanding tradition of landscape photography, I have depicted scenes of land use and neglect, of consumption, waste and abandonment along the highways of the American West. I've also attempted to convey a psychological milieu, and an imagined future: a tableau that relays something of the complexity of the conflict between humanity and nature. Approaching these scenes both literally and allegorically is a way of addressing my own anxieties about the future of industrial civilization, and what this way of life portends.

To me, the word irresistible has always had a negative connotation, one that relates to temptation; it describes something that feels good in the moment but might have adverse consequences in the future. My initial inspiration was America's car culture and the depletion of natural resources and fossil fuels in a car-crazed society. I also looked inward, acknowledging that I am part of a destructive consumer culture—using energy, buying cheap goods, putting fuel in my car. Like so many others, I find this convenient at present, but am contributing to gigantic dilemmas in a globalized society.

Much of this destructive activity takes place in a suburban landscape, but I decided to focus rather on places where industrialized culture meets the frontier. Here, in the vastness of the American West, there is greater tension as the battle seems neither lost nor won. The efforts of humans are measured against the apparent eternity of geology and the natural world, reminding us of the brevity and frailty of our civilizations.

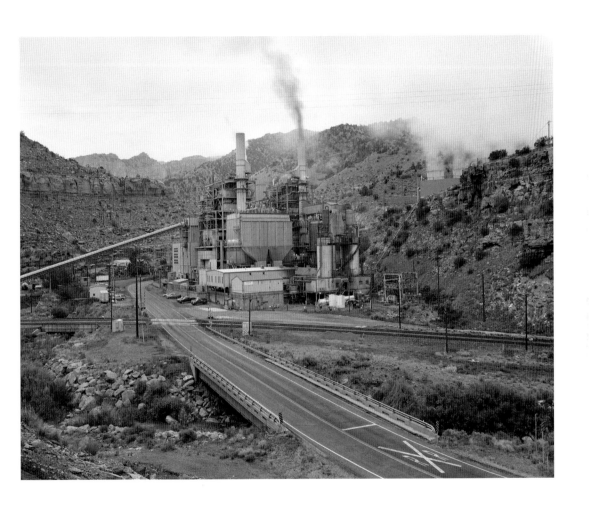

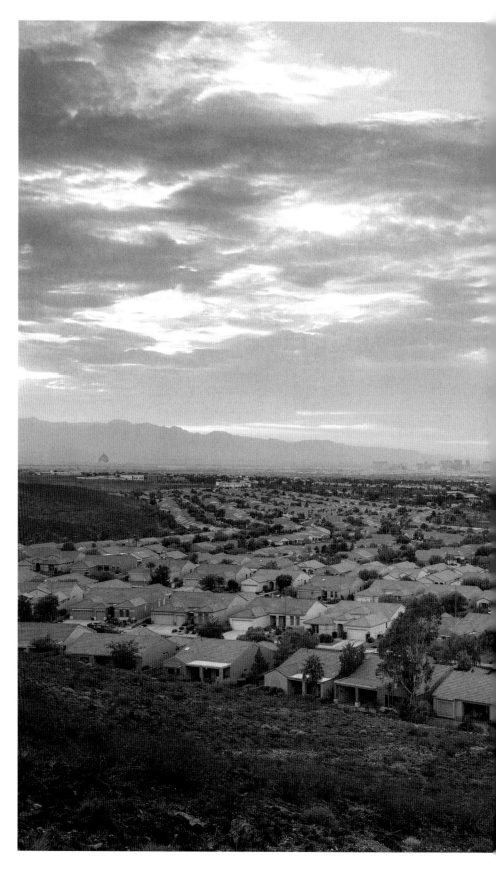

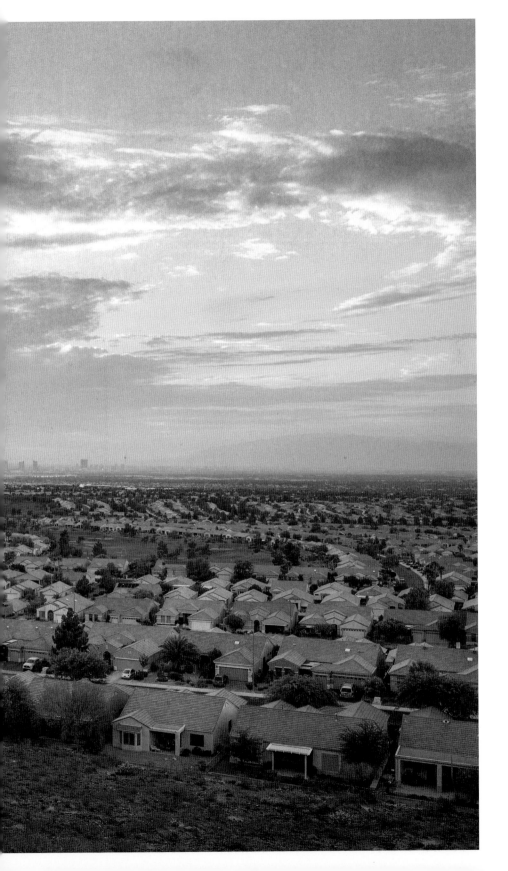

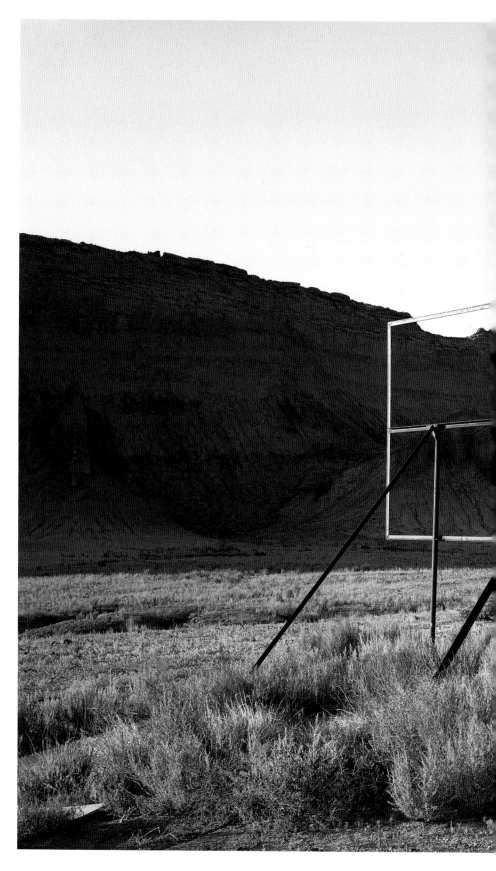

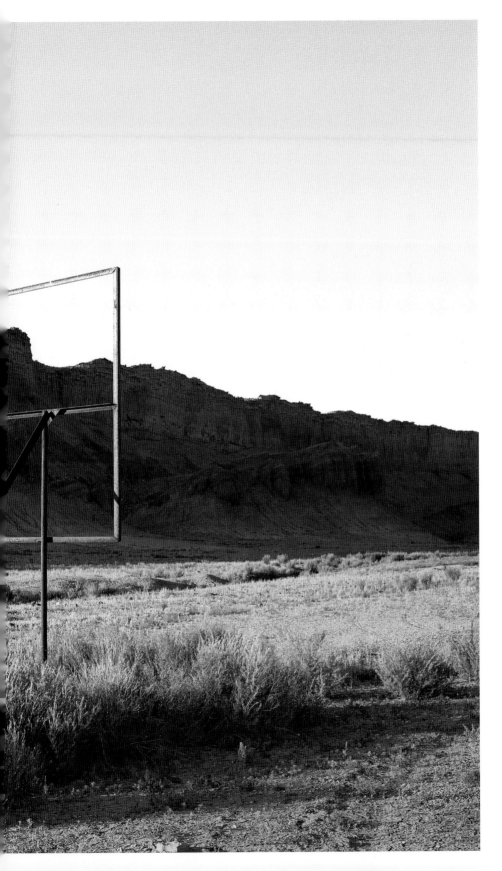

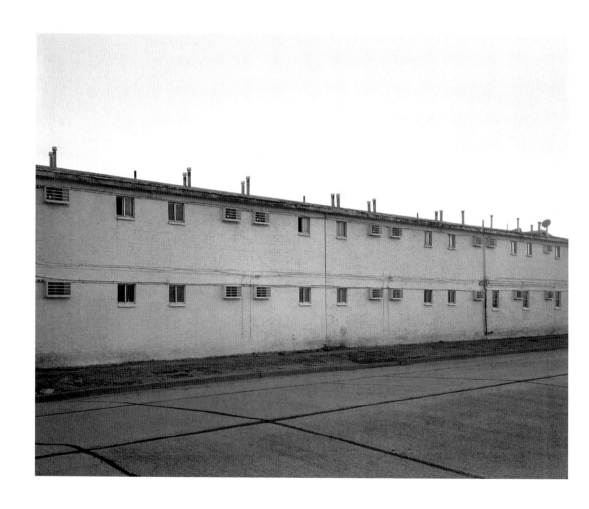

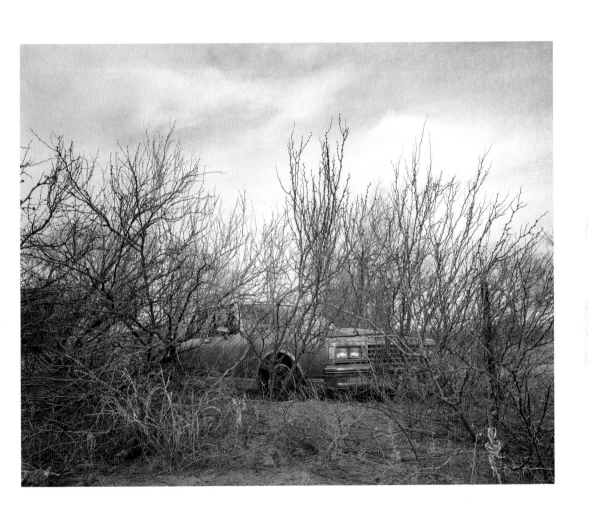

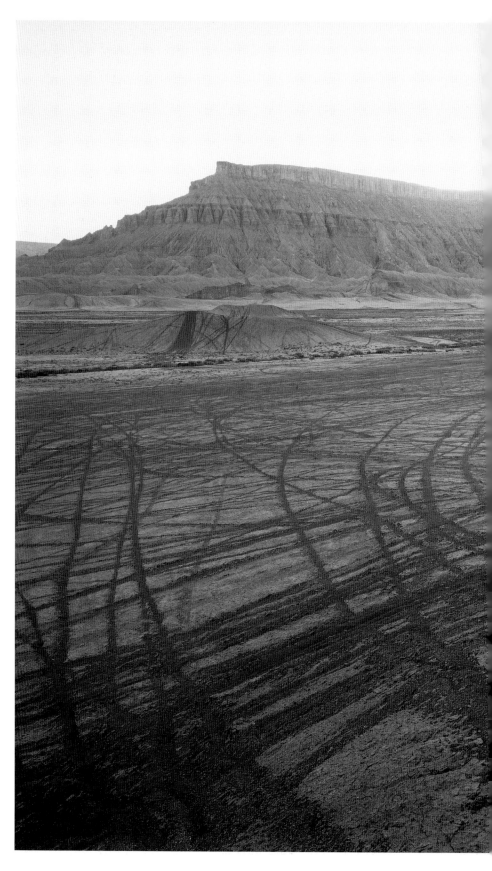

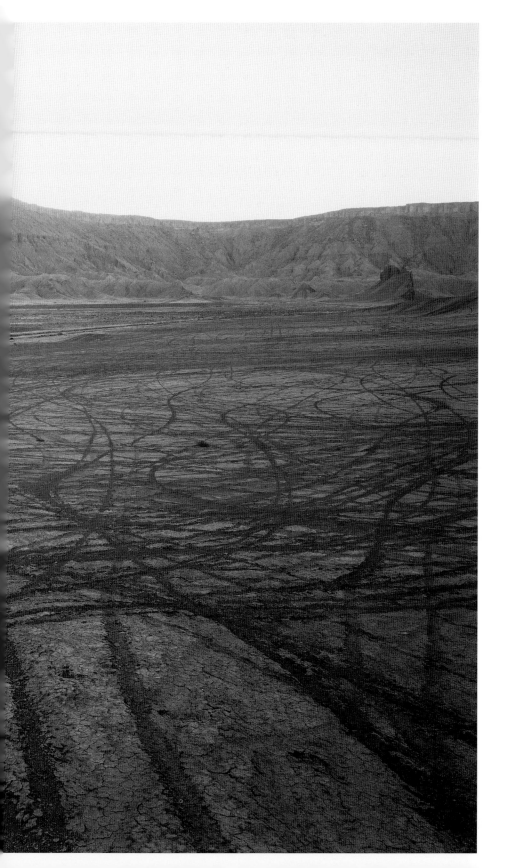

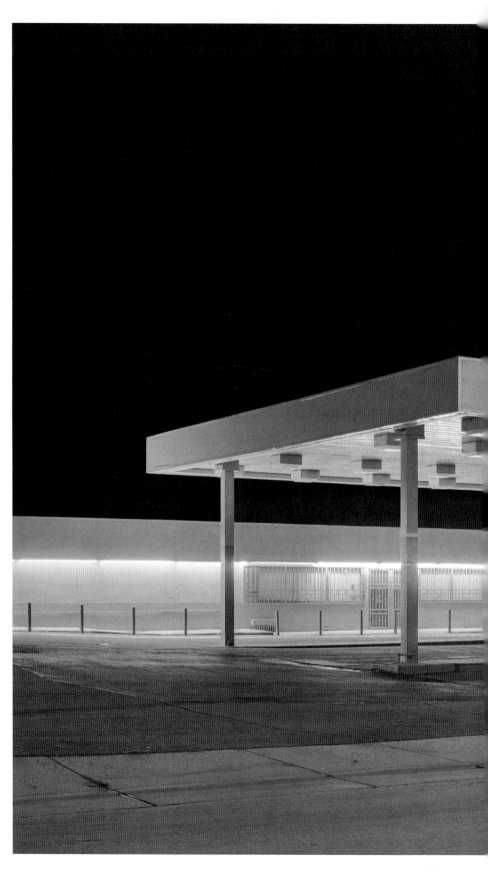

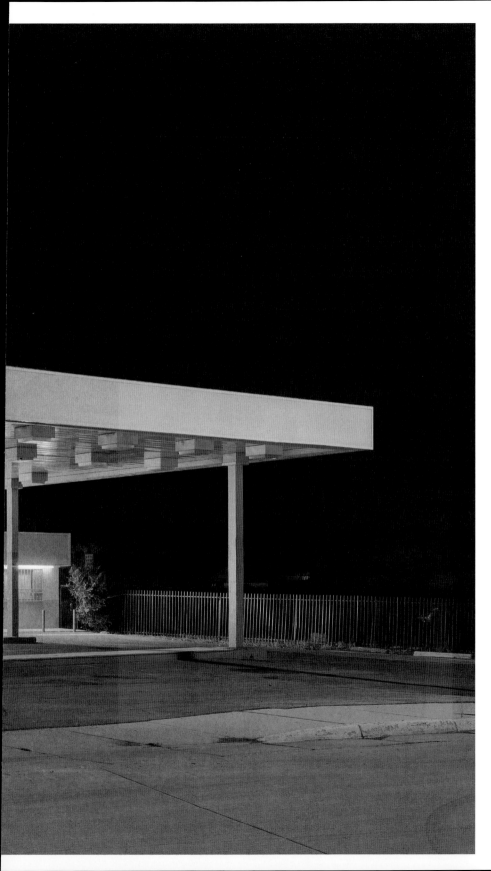

You'll Know It
When You Feel It

Raphaela Rosella

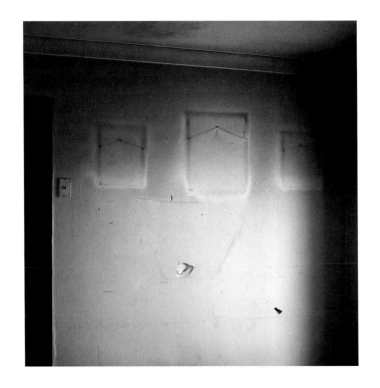

The aftermath of a house fire at a home in Moree, New South Wales.
Family portraits were saved, leaving outlines of smoke damage on the wall.

Many disadvantaged communities in Australia face entrenched poverty, racism, trans-generational trauma, violence, addiction, and a range of other barriers to health and wellbeing. Having grown up in one such community, I am particularly concerned with the challenges faced by young women. Being without love in an environment where belonging is critical, can leave a woman vulnerable to additional hardship, such as social isolation. This has led me to explore the tensions between love, longing, and belonging in such a context.

You'll Know It When You Feel It is a reflection of loss, hope, vulnerability and resilience. It offers glimpses into the lives of young women, their families and their struggles, to make clear that love and belonging are irresistible in the face of adversity.

I grew up in a socio-economically challenged town, and experienced first-hand the difficulties of leading a life outside my community. But while there certainly was hardship, chaos and dysfunction, I also experienced a strong sense of belonging, through an extended family and tight-knit community. Despite my community's hardship, I am continually drawn back to my hometown. It is through this personal experience that I was led to interpret the theme of 'Irresistible' as a sense of longing and belonging.

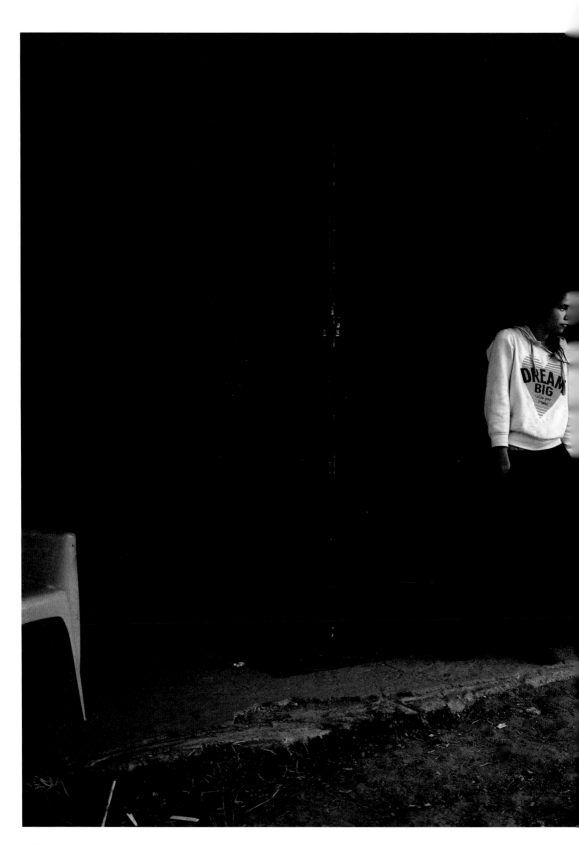

Shavanni stands outside her family home in Moree. She has eight siblings, including an elder brother who is serving time in jail.

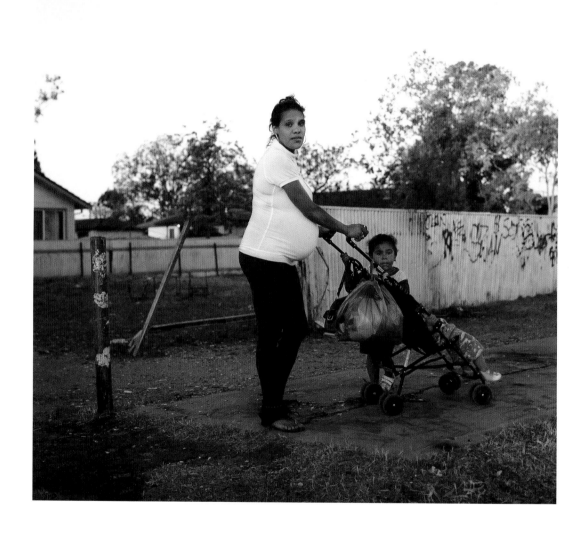

"I got my kids, that's all I ever wanted." Rowrow walks to bingo with her son, Baby Shane, and her daughter, Princess. Another baby is due in a few weeks' time.

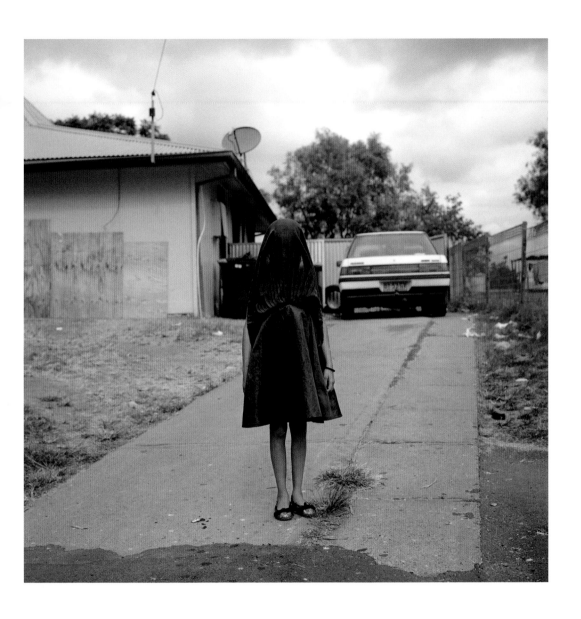

Laurinda waits in her purple dress, for the bus that will take her to Sunday school, in Moree, New South Wales.

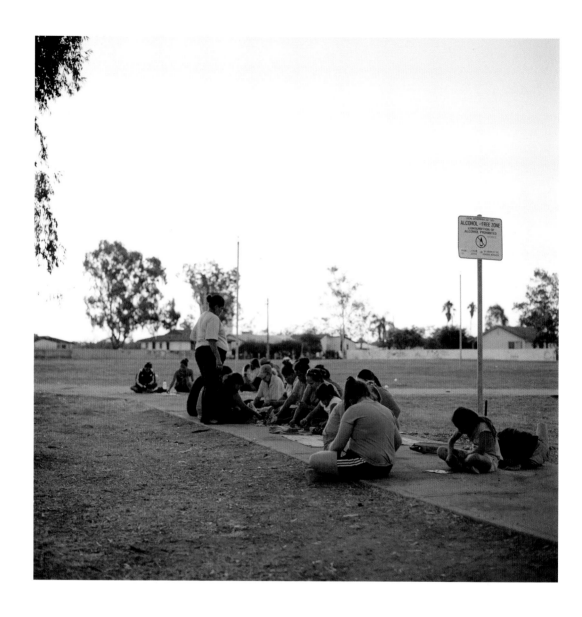

A bingo session, in Wales Park, Moree.

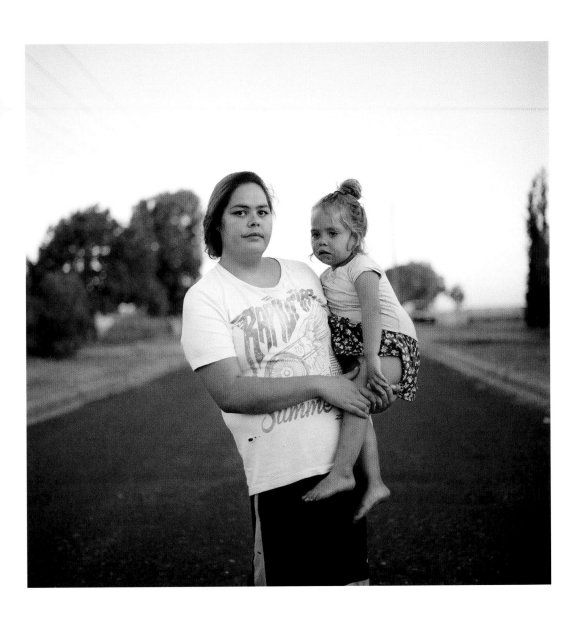

Tearna carries her daughter Rowena, in Tawarri Street, Moree.

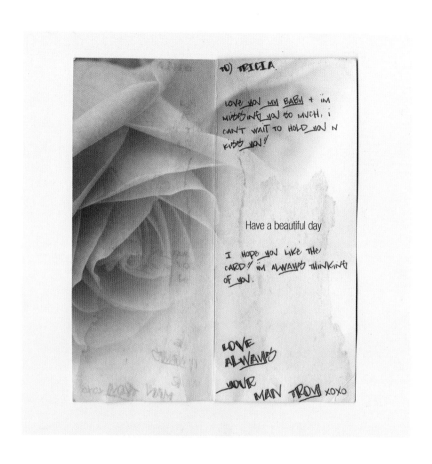

A love letter sent to Tricia from her boyfriend, who is serving time in a jail in Queensland.

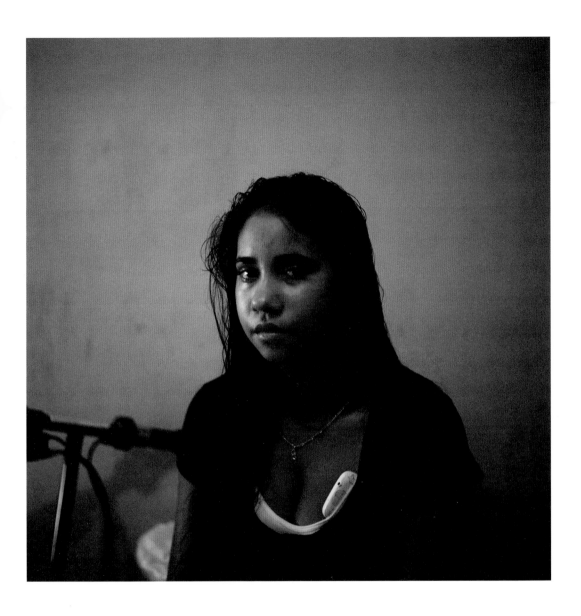

"He's like a gentleman. He's not like any of the other fellas around here," says Tricia.

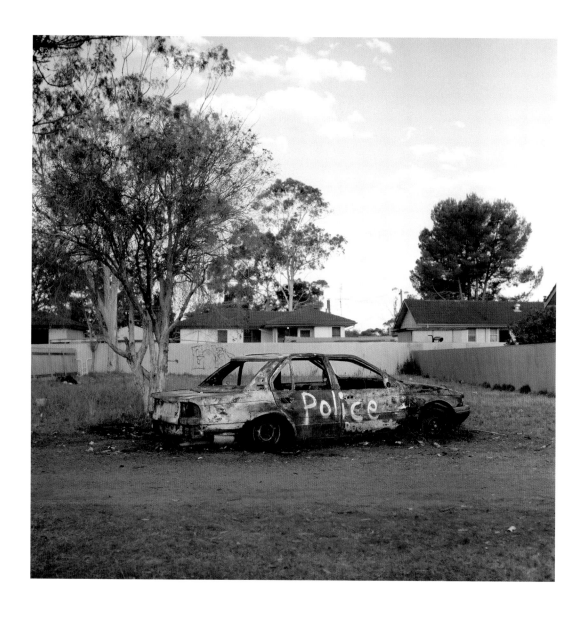

The remains of a burnt-out stolen car, in a vacant lot in Arunga Street, Moree.

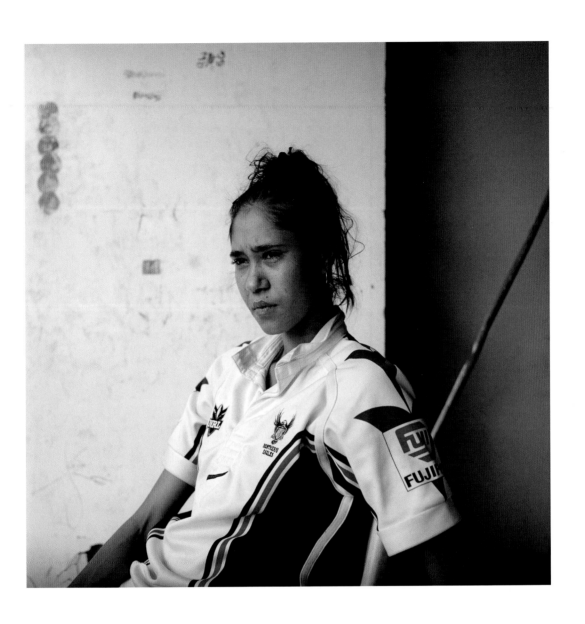

Ashanti, in Dingwall Place, Moree.

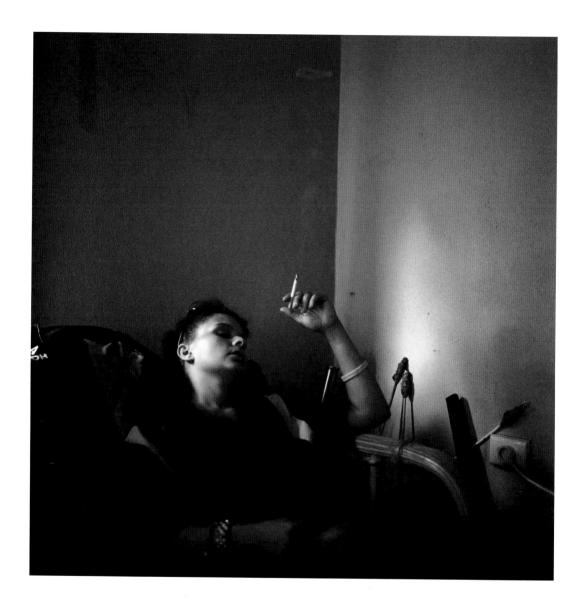

"I've never had that love and affection from nobody, hence why I crave it so much. I crave it. I want what's in the movies, but I'll never get it." Tammara sits in her new boyfriend's small bedroom. She recently gave up her daughter Tamika, because she felt she couldn't keep her safe from a former partner's extreme violence. She says she has lost everything: daughter, house, and all her belongings.

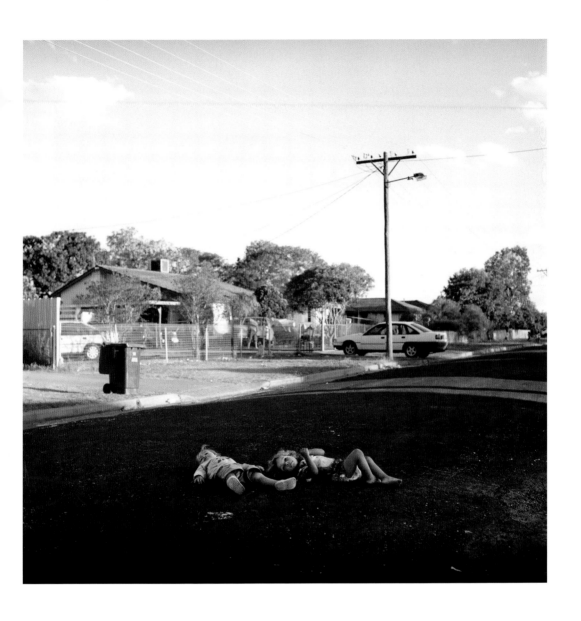

Princess and Wonna play in the road, on Tawarri Street, in Moree.

Akos Stiller (32)

was born in Budapest, Hungary. In 2007 he started to work as a professional photographer for the Hungarian weekly *HVG*, and currently works on assignment for *National Geographic*, *The New York Times*, *The Washington Post*, and for Bloomberg. Over the years, Akos has won 14 awards in the Hungarian Pictures of the Year, including the best photo-journalist under 30, and for the best portfolio. Akos is currently working on documenting the daily life on Hungarian steppe, the Puszta.

Andrejs Strokins (30)

was born in Latvia, and holds a BA degree in graphic printmaking from the Art Academy of Latvia. In 2006, he started work as a professional pho-tographer for AFI press photo agency. Andrejs' interest in long-term docu-mentary projects increased after taking part in ISSP summer work-shops in 2009. Since 2011, he has worked on a freelance basis, and continues to pursue documentary projects based on the daily life of ordinary people. His work has been recognized by numerous awards, including Top 50 LensCulture Emerg-ing Talents 2014, La Quatrième Im-age, and Kaunas Photo Star 2013.

Bego Antón (31)

was born in Bilbao, Spain. She studied journalism at the University of the Basque Country, specializing in documentary photography. Her photographic work usually explores the love-hate relationship humans have with nature and animals. She also has a particular interest in the small groups that seem strange to the larger part of society.

Bryan Denton (31)

is a freelance photographer based in Beirut, Lebanon. He began his career covering cultural issues and conflicts in the Arab world, after graduating from New York University's Tisch School of the Arts, where he focused on photography and Middle Eastern and Islamic studies. Based in Lebanon since 2006, Bryan is a frequent contributor to *The New York Times*, and has also completed assignments throughout the Middle East, North Africa, and Afghanistan for *Time*, *Newsweek*, *Stern*, *The Wall Street Journal*, *Vanity Fair Italy*, *Der Spiegel*, *Monocle*, and Human Rights Watch. Bryan's work has also been recognized by the Chris Hondros Foundation, The Magenta Founda-tion, Prix de la Photographie Paris (Px3), Le Prix Bayeux-Calvados and Foto8, among others.

Bryan Schutmaat (31)

is an American photographer whose work has been widely exhibited and published. He has earned numerous awards and honors, including an Aperture Portfolio Prize, a Center's Gallerist's Choice Award, a Daylight Photo Award, and the PDN's 30 selection, among many others. His first monograph, *Grays the Mountain Sends*, was published by the Silas Finch Foundation in 2013 to international critical acclaim. His photos can be found in the perma-nent collection at the Baltimore Museum of Art, the Museum of Fine Arts, Houston, and numerous private collections. He lives in Austin, Texas, and is represented by Sasha Wolf Gallery in New York City.

Émilie Régnier (30)

was born in Montreal, Canada. She spent most of her childhood in Africa, mainly in Gabon. After photography studies in Montreal, she lived in Senegal, where she has been working for the past three years. She is now based in Ivory Coast. Émilie has covered various events in and around West and South Africa, the Middle East, Eastern Europe, and the Caribbean. Her work has been featured in newspapers and magazines such as *The New York Times*, *Courrier international*, Le *Monde Magazine*, *Libération*, *Der Spiegel*, *Le Journal du Dimanche*, *Journal La Croix*, *Elle Belgique*, *Elle France*, *Jeune Afrique*, *l'Actualité*, and *Chatelaine*, among others.

Giorgio Di Noto (24)

was born in Rome, Italy, where he still works and lives. He studied photography at Centro Sperimentale di Fotografia Adams, and learned darkroom and printing techniques working with some master printers in Italy. He is currently studying philosophy at the Sapienza University of Rome. Giorgio was selected for the Reflexions Masterclass in 2012. In 2012, Giorgio won the Marco Pesaresi Prize with his project 'The Arab Revolt', and his work has been included in *The Photobook: A History, Vol. III* by Martin Parr and Gerry Badger.

Ilona Szwarc (30)

is a Polish-born artist based in New York City. She holds a bachelor's degree in fine arts from the School of Visual Arts in New York City, and she is currently pursuing a graduate degree in photography at Yale University. Ilona has held solo exhibitions in New York, Paris and Lille, as well as group shows internationally. Her awards include an Arnold Newman Prize, a World Press Photo award, and accolades from PDN. Ilona's work has been featured in numerous publications worldwide, including *The New York Times Magazine*, *Time*, *The New Yorker* and *The Telegraph Magazine*. Her projects 'American Girls' and 'Rodeo Girls' have received worldwide recognition.

Isadora Kosofsky (21)

is a Los Angeles-based documentary photographer. She received the 2012 Inge Morath Award from the Magnum Foundation for her multi-series documentary about the lives and relationships of the elderly. Her work has received distinctions from Women in Photography International, Prix de la Photographie Paris (Px3), and The New York Photo Festival. Isadora's projects have been featured in Time Lightbox, *Le Monde*, The Huffington Post and *The New Yorker* Photo Booth, among others. Her documentary shadowing the life and incarceration of two brothers was recently published in Time Lightbox.

Meeri Koutaniemi (27)

is a freelance photographer, who was born in Lapland and currently lives around the world. She began her career as a photojournalist shooting independent projects abroad, and now does documentary stories on issues concerning human rights and minorities, combining her work with political activism. Meeri has worked as a photographer and a journalist in over 30 countries. In 2012 and 2013, she was chosen as Photographer of the Year by the Finnish press photographers' association. In 2014, she won the Freelens Award at the Lumix photo festival in Hannover, with her exhibited documentary work 'Taken'. Meeri is a founder member of the Italian Echo Photo Agency, and belongs to the Finnish collective 11 (Yksitoista).

Raphaela Rosella (26)

is an Australian documentary visual-storyteller. Currently based in Brisbane, she is co-editor of *The Australian PhotoJournalist*, a non-profit publication dedicated to celebrating the human condition and casting a critical eye on journalism and mass media practices. Working closely across communities facing recurring hardship, Raphaela uses visual storytelling to question our readiness to stigmatize and to stereotype. Known for her work documenting the lives of several young mothers, Raphaela plans to continue investigating relationships between social class, stigma and gender among young Australian women and men experiencing social disadvantage. In 2012 she joined the Australian photography collective Oculi and is now represented throughout Europe by Agence Vu.

Sarker Protick (28)

was born and raised in Dhaka, Bangladesh. As a teenager he wanted to be a musician and songwriter, but discovered photography around the age of 24, when visiting the Chobi Mela Photography Festival. After finishing a bachelor's degree, he enrolled at Pathshala South Asian Media Institute. As a photographer, Sarker wants to tell stories previously unheard from his country, and to challenge visual stereotypes. He is currently teaching at Pathshala.

About the Joop Swart Masterclass

The Joop Swart Masterclass offers a focused, intimate and reflective learning experience to young photographers, aiming to foster their intellectual, artistic and professional growth. Twelve participants meet with six experts for a week in Amsterdam in November, to discuss technical, journalistic and ethical aspects of their work. The dialogues the young photographers engage in, and the contacts they make, help sustain their future professional development.

Acceptance to the masterclass is exclusively by nomination and selection. In 2014, 120 international experts nominated 141 young photographers, representing 53 countries from across the world, and invited each to submit a portfolio of work for consideration. Twelve finalists were selected to participate in the 2014 Joop Swart Masterclass, free of costs, and assigned to shoot a photo story on the theme 'Irresistible'. These stories have been collected in this book.

Since 1994, the Joop Swart Masterclass has brought together some of the finest young photographers from around world, and leading professionals in the fields of documentary photography and photojournalism. The masterclass holds prime position among the seminars, debates and other educational programs regularly organized by World Press Photo Academy. It is named after the foundation's late chairman, who was a passionate supporter of young photographic talent.

See each photographer's personal edit of their photo story in an online gallery, together with videos and photos of the masterclass sessions, on worldpressphoto.org/academy.

Project manager Joop Swart Masterclass
Rebecca Simons

World Press Photo
Jacob Obrechtstraat 26
1071 KM Amsterdam
The Netherlands
Tel. +31 (0)20 676 6096
Fax +31 (0)20 676 4471
office@worldpressphoto.org
www.worldpressphoto.org

World Press Photo wishes to thank:

Masters
Frank Kalero, Spain, cultural manager, publisher and curator
Yuri Kozyrev, Russia, photographer Noor
Meaghan Looram, USA, deputy editor of photography *The New York Times*
Hellen van Meene, the Netherlands, artist
Sujong Song, South Korea, independent curator and photo editor
Donald Weber, Canada, photographer VII Photo Agency

Sponsors
The Joop Swart Masterclass is supported by Ammodo Foundation, Corbion and Canon, who provides all participants with a grant.

World Press Photo receives support from the Dutch Postcode Lottery and is sponsored worldwide by Canon.

Corbion

Next#04
Copyright © 2014
Stichting World Press Photo, Amsterdam, the Netherlands
Schilt Publishing, Amsterdam, the Netherlands
www.schiltpublishing.com
All photography copyrights are held by the photographers

Editorial team
Kari Lundelin
Titus Sauerwein
Rebecca Simons

Text
Rodney Bolt

Art director
Teun van der Heijden

Design
Heijdens Karwei, Amsterdam
www.heijdenskarwei.com

Print & logistic management
KOMESO GmbH, Stuttgart
www.komeso.de

Lithography and printing
Offizin Scheufele, Stuttgart
www.scheufele.de

Distribution in North America
Ingram Publisher Services
One Ingram Blvd.
LaVergne, TN 37086
IPS: 866-765-0179
customer.service@ingrampublisher
services.com

Distribution in the Netherlands and Belgium (Flanders)
Centraal Boekhuis

Distribution in all other countries
Thames & Hudson Ltd
181a High Holborn
London WC1 V 7QX
Phone: +44 (0)20 7845 5000
Fax: +44 (0)20 7845 5055
sales@thameshudson.co.uk

ISBN 978-90-5330-838-7

Cover photograph
© Émilie Régnier